D1060855

ARTS · & · CRAFTS TEXTILES

The Movement in America

Ann Wallace

With photography by Phil Bard

GIBBS·SMITH
P
PUBLISHER

Salt Lake City

Dedicated to Helen Brandebury Harvey, 1893-1984,
and Addilah Mason Wallace, 1899-1987.

∶

First edition
03 02 01 00 99 5 4 3 2 1

Copyright © 1999 by Ann Wallace

All rights reserved. No part of this book may be reproduced by any means whatsoever, either mechanical, electronic or digital, without written permission from the publisher, except for brief excerpts quoted for the purposes of review.

Permission has been granted by F. Schumacher & Co., an exclusive licensee of the Frank Lloyd Foundation, to use copyrighted design on page 19. Design © The Frank Lloyd Wright Foundation.

Published by
Gibbs Smith, Publisher
P.O. Box 667
Layton, Utah 84041

Orders: (1-800) 748-5439
Web site: www.gibbs-smith.com

Cover design by Traci O'Very Covey
Book design and production by Kathleen Timmerman
Printed and bound in China

Library of Congress Cataloguing-in-Publication Data
Wallace, Ann, 1949–
 Arts & Crafts Textiles / Ann Wallace.
 p. cm.
 Includes bibliographical references.
 ISBN 0-87905-908-7
 1. Textile crafts—United States—History. 2. Textile fabrics in interior
 decoration—United States—History. 3. Arts and crafts movement—United
 States—History. I. Title. II. Title: Arts and crafts textiles.
TT699.W337 1999
746′.0973—dc21
 99-26506
 CIP

CONTENTS

ACKNOWLEDGEMENTS

Many thanks to all the artisans and collectors who generously gave me advice and suggestions. Thanks also to my clients who put up with the occasional delay while I met deadlines.

This book would not exist without Phil Bard's breathtaking photographs, his expert knowledge of Pasadena locations, and his advanced computer skills.

Suzanne Taylor, my editor at Gibbs Smith, was somehow simultaneously charming, heroic, supportive, and relentless.

Ann and Andre Chaves, Heather McLarty, and Troy Evans and Larry and Gioia Pastre earned halos for allowing us to rearrange their beautiful homes and lives.

Most of the textiles we photographed come from the collections of Rosemary and Ed Kostansek, Ken Fearing, and Tim Counts, all of whom generously trusted us with their beautiful things. Special thanks to Ken who has been advisor, partner, and design assistant from the beginning.

David Heide, Suzanne Maurer, and Marti Wachtel managed, under incredible pressure, to send us photographs of their design projects. I'm especially grateful to David who started the whole thing.

Thanks to the Minneapolis Institute of Art and Art Institute of Chicago for access to their collections and to the main branch of the Los Angeles Public Library, a great and unappreciated resource.

Bruce Smith and Yoshi Yamamoto and Dianne Ayres and Timothy Hansen gave consultations, referrals, and advice.

Lew and Cathy Phelps first brought me to Pasadena, Arts & Crafts Mecca Extraordinaire.

On a personal note, I relied on the support of my mother, Ida Wallace, my sister, Jane Wallace, and my father, Kenneth Wallace. A deep curtsy to my email posse who gave me a life when I was chained to the computer, to Vince for believing in me from the beginning, and to Stan, who reminded me of why I was doing what I was doing.

Ann Wallace
Los Angeles, 1999

PREFACE

When I started my own Arts & Crafts textile business nine years ago, I was immediately struck by how intertwined the early movement was with the increasing freedom and independence of women. From the "Aesthetic" dress of the Pre-Raphaelites that liberated women from tightly laced corsets to the efforts of needlework societies that encouraged women of all classes to earn their own money, the Arts & Crafts movement has provided an aesthetic context for some dramatic social change. The gentle feminism of the Arts & Crafts movement was particularly acceptable, associated with the home, children, and the traditional feminine skill of needlework. Today many romanticize a past when women could supposedly afford to stay at home with their children, so it is surprising to find the magazines of the period encouraging women's financial independence. These magazines had an enormous circulation and represented mainstream views, at least about how women saw themselves. Magazines were directed at different levels of income and education. For example, *Needlecraft* was directed at a working-class audience while *The Modern Priscilla* was intended for a more affluent group. *Needlecraft* often printed articles on earning money with needlework or even working outside the home in the rapidly expanding home-sewing industry. *The Modern Priscilla* gently promoted higher education for women and friendship with new immigrants.

The lives of my grandmothers were representative, in different ways, of the interrelationship of all these trends. My maternal grandmother, Helen Brandebury Harvey, was the beloved daughter of a doctor who believed in education for women. She became interested in Elbert Hubbard as a teenager and delivered her high-school valedictory address on the Roycrofters. She attended the University of Michigan and became friends with Hubbard's daughter. She purchased items from the Roycroft Shops and owned five complete sets of Hubbard's *Little Journeys*. Her house had a sewing room, and she always sewed, although she used a dressmaker even during the depression. Some of my most valuable vintage needlework magazines come from her attic. After her children were grown, she went back to school, completed her doctorate at Columbia University, and became an English professor.

My father's mother, Addillah Mason Wallace, grew up in rough conditions in Idaho where her parents were homesteaders. Because the other students made fun of her clothes, she quit school in the eighth grade. She worked full time outside the home, in factories, all her adult life. Somehow, while holding down a physically exhausting job, she put up preserves, canned vegetables, made sauerkraut, raised two sons, and became an expert needleworker. She trimmed her bed linens with elaborate crochet and embroidery and turned out literally hundreds of intricately stitched quilts. She won many awards at state and county fairs, most famously a blue ribbon for an elegantly crocheted tablecloth. I often think of her when I hear women say they are too busy to sew.

The life patterns of my grandmothers seem remarkably modern to me, and yet, reading through the magazines of the period, they were probably not so unusual. In fact, the similarities in women's lives, then and now, seem more significant than the differences. Reading through the magazines and handling the textiles, I felt a connection to all these women, as if, through some direct transmission involving needle and thread, I am just continuing their work.

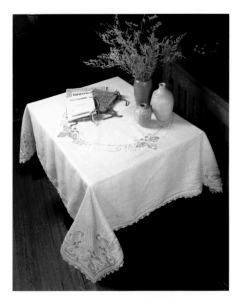

Linen tablecloth from the collection of
Rosemary Kostansek.
PHOTOGRAPH BY PHIL BARD

INTRODUCTION

This book is intended as a beginning guide to American Arts & Crafts textiles. While excellent books are available on the work of European designers in this style, little has been written about American textiles. Most American Arts & Crafts textiles were made at the beginning of the twentieth century, when the sewing industry had become increasingly commercialized. Most needlework pieces were made from mass-produced kits, and not all the women who purchased these kits were equally skilled with a needle. The uneven quality of the finished work made early-twentieth-century embroidery less attractive to collectors.

Today, however, a new appreciation has developed for the more vernacular elements of the American Arts & Crafts movement and their unique contribution to the creation of a decorative and architectural style specifically directed at those with a modest income. Vintage textiles have become more valued and more expensive, and contemporary designers offer kits and finished textiles as well.

An appreciation of the value of handwork has always been an important element of the Arts & Crafts movement. The embroidery kits of the period and of the present time are often specifically intended to provide some of the rewards of needlework for beginners. I urge you to take the time to make a simple pillow or table runner. If you have not previously done any sewing, the process will enhance your appreciation of the textiles you purchase, and you may be surprised at how fulfilling it can be to complete a project yourself.

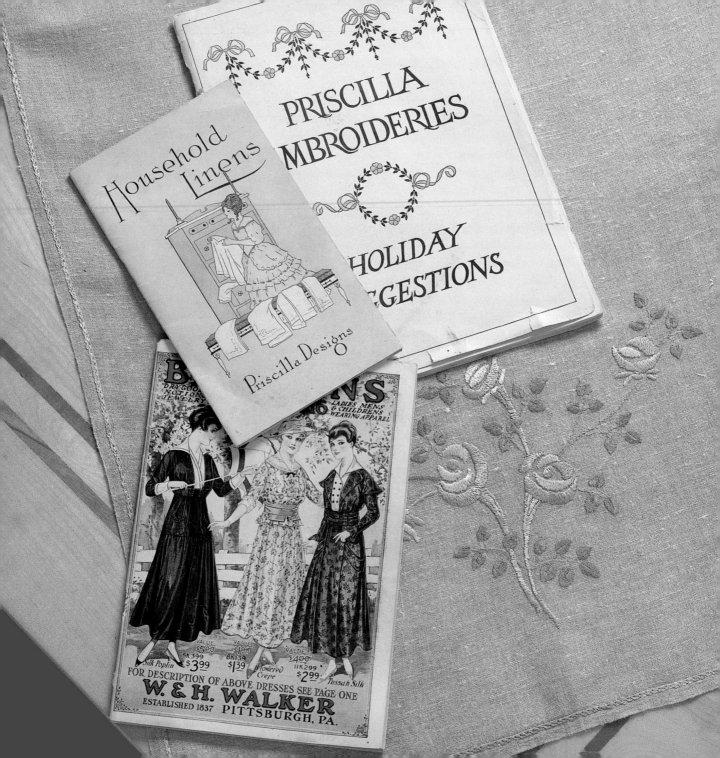

A BRIEF HISTORY

"We can add very little to these necessities [of life] without troubling ourselves and hindering our work, our thought and our rest. It may also be added that as richness does not entail luxury—that foe of art and forerunner of degeneracy—so simplicity does not necessitate cheapness, and that these objects should include none that have degraded a man to make, or to sell."
—*Gustav Stickley*

The Modern Priscilla and other women's magazines of the period aggressively promoted embroidery with complementary booklets and needlework clubs. Documents from the collection of the author, embroidery from the collection of Rosemary Kostansek.

PHOTOGRAPH BY PHIL BARD

In early-nineteenth-century Great Britain, advances in mass production (a result of the Industrial Revolution) made many luxuries available to men and women of modest means that were formerly only for the very wealthy. Machine-turned wood duplicated hand carving. Huge textile mills wove and printed fabrics that had previously been produced by a few people in a small shop. Hand-painted china was imitated with transfer printing. Yet, to many people, these goods were devalued not only by their easy availability but by the absence of any indication that a human artisan had made them. The designer seemed increasingly cut off from the craft and skill required to produce what he had designed. The natural simplicity and elegance that resulted when highly skilled human labor planned and made an object seemed to be corrupted by the ease of ornamentation and absence of technique.

There was certainly an element of snobbery in these ideas, which came mostly from highly educated members of the upper class. However, they advocated a high regard for simple laborers as well as skilled artisans, and the Arts & Crafts movement became closely tied to early socialism and political activism.

The first inspiration came in the Middle Ages. Artisans of this time seemed to perfectly blend skill and practicality without recourse to externally imposed canons of proportion and design. A. W. N. Pugin, the architect who

designed the British Houses of Parliament and a theorist of the Gothic Revival, wrote of "the fitness of the design to the purpose for which it is intended," and rejected the formalism of the Classic Revival. John Ruskin, the curmudgeonly art historian and founding theorist of the Arts & Crafts movement, wrote his defining work, *The Seven Lamps of Architecture*, in 1849. He pleaded for a renewed appreciation of handmade roughness, argued for simpler design at affordable prices, and urged eliminating the artificial split between the artist and the craftsman. He believed that the mason should design his own building and the artist must grind his own pigments. His writings gave the movement its name and inspired its most famous advocate, William Morris (1834–96).

Morris was associated with the Pre-Raphaelite brotherhood, which included, among others, the painters Dante Gabriel Rosetti, William Holman Hunt, and John Everett Millais. They vowed to seek inspiration only from art produced before the birth of the Italian painter Raphael; in other words, before the formalism of the High Renaissance. Morris soon found his true calling as a designer, opening his first design firm in 1861 to produce needlework designs, printed wallpaper and fabric, carpets, tapestries, and other home-furnishing products, many of which are still manufactured today. His color schemes, use of allegorical figures, and highly stylized natural forms were greatly influenced by the fine surviving examples of medieval needlework available in England.

"Decorative Needlework" by William Morris's daughter, Mary Morris, 1893, Edition deluxe, consisting of 125 copies only, of which this is copy no. 32, from the collection of Timothy Hansen and Dianne Ayres.

Needlework was then, as now, considered a mainly feminine occupation. Morris taught his wife—the artist's model and renowned Pre-Raphaelite beauty Jane Morris—to sew the tapestries and cushions he designed. His daughter, Mary Morris, started helping him in his studio as a child. Later she managed his needlework business and became a respected designer in her own right.

Influenced by the Arts & Crafts movement, educated upper-class women showed a great interest in fine sewing, now associated with fine feelings and an aesthetic view of life. They distinguished their embroidery from other sewing by emphasizing a careful study of antique styles, a commitment to good design, and a use of softer faded colors. These women were frequently lampooned for their use of "dowdy" colors, for their obsession with medieval and ecclesiastical design, and for their attempts to create "artistic" homes. In the Gilbert & Sullivan operetta *Patience*, they were represented as wandering soulfully around in aesthetic drapery, carrying lilies and striking medieval poses. But they were also tireless promoters who commissioned designs from noted artists and architects and started societies and guilds to encourage actually paying women for their skills with a needle.

The most important of these organizations was the Royal School of Needlework, founded in 1872 to create a professional workroom to manufacture finished work and to repair historic embroidery. The organizers were mainly members of the British nobility with H. R. H. Princess Christian as president. This lent a certain patronizing quality of noblesse oblige to their efforts to promote embroidery as an artistic profession. Nevertheless, they were enormously successful in elevating the perception of embroidery from a pleasant distraction for otherwise idle women to a respected profession. In promoting art needlework as a business, they also popularized it as a leisure activity.

The Royal School of Needlework came to the United States for the Philadelphia Centennial Exhibition in 1876 and inspired Americans to start their own organizations. A Needlework & Textile Guild was set up at the Art Institute of Chicago; the Boston Museum of Fine Arts had a School of Needlework, and other cities followed.

The most influential, however, was the Decorative Arts Society in New York founded by Candace Wheeler (1827–1923) and several New York society figures. Later, Wheeler joined Louis Comfort Tiffany in an organization of designers called Associated Artists. The elaborately embroidered draperies and portieres she produce for Associated Artists were highly influenced by British art needlework and the British Aesthetics movement. Wheeler was an inspiring lecturer and teacher as well as a gifted designer and skilled embroiderer. She probably was the single greatest influence on the revival of embroidery in the United States. She also designed printed fabrics, and, living to be ninety-five, she was an enduring influence on textile design.

Candace Wheeler

Wheeler was born Candace Thurber in upstate New York. Her parents were abolitionists and her childhood home was a station on the Underground Railway. Her family did not use cotton because it was the product of slave labor, and her earliest memories were of her mother's fine homespun linen. She married an engineer and businessman and moved to New York, where she soon became involved in the growing art and design scene. In 1876, she attended the Philadelphia Exposition and saw the work of the Royal School of Art Needlework. She was actually unimpressed by the quality of the stitching, but she was inspired by the blend of social idealism, art, and capitalism. She wrote, "It interested me extremely, for it meant the conversion of feminine skill in the use of the needle into a means of art-expression and pecuniary profit . . . It was the beginning of self-help among educated women."

At age forty-nine, Wheeler founded the Society of Decorative Art and began teaching and promoting fine needlework. When the stress of organizing and collaborating took its toll, she joined with Louis Comfort Tiffany, starting Associated Artists to produce her own work. The members of Associated Artists soon went their separate ways, and Wheeler began designing printed fabrics and wallpapers as well as embroideries. She traveled extensively and associated with luminaries of the Aesthetics movement in America and Great Britain. She continued writing, teaching, and experimenting with dyes and developed her most popular and commercially successful textiles, block prints on American denim.

Document reproductions of Candace Wheeler's printed textiles for Associated Artists (c. 1885–1905) by Burrows Studio. "Carp" in purple on olive denim and "Seashell & Ribbon" in sepia and yellow.

PHOTOGRAPHS BY
PHIL BARD

In textile design, sources and influences often overlap. William Morris was a strong influence in Europe as well as in the United States. Another designer from the British Isles was also a great influence on later European and American textile design. Charles Rennie Mackintosh (1868–1928) was born and worked mainly in Glasgow, Scotland. Glasgow was an extremely important trade and manufacturing center in the nineteenth and early twentieth centuries. It enjoyed much more international culture than London and turned more to Europe than Great Britain for artistic influences.

Mackintosh was trained as an architect but is probably best known for his distinctive graphics, furniture, and other decorative arts. He and his wife, Margaret McDonald, are the most famous members of the circle of artists associated with the Glasgow School of Art. The headmaster of the school, Frances

Newbery, started an art club in 1889 to promote the New Art. His wife, Jessie Newbery (1864–1948), taught embroidery at the school and, through her teaching and creating her own designs, popularized Glasgow embroidery to such a degree that it was considered by many to be the best representation of the Glasgow School style. Jessie Newbery emphasized design over technique and insisted that quality needlework could be available to all classes and skill levels. She often worked with inexpensive fabrics such as calico and flannel. Although her pattern designs were complex, she used the simplest possible stitching and popularized the use of appliqué to fill in large areas of color.

The distinguishing features of the Glasgow School style (also called the New Art) are its strong use of line, giving embroidery the qualities of a drawing rather than a painting. Compositions were also often decorated with squares and circles, as if the line itself was breaking up. Natural forms were highly abstracted; figures as well as flowers and plants were reduced to flattened, geometric shapes. The most famous of these, the Glasgow Rose, was first used by Newbery as an appliqué motif. It was soon adopted by other artists and became a kind of logo for the movement. The color palette of the Glasgow School was distinctive and quite different from that of the British Arts & Crafts movement. It often used bright white and a strong black line with pinks, lavender, and purple.

Not long after the Glasgow Art Club began, a group of artists in Vienna followed a similar path. Reacting to the formalism of the conservative Kunstlerhaus, in 1897 they founded a group called the Secession. Vienna, a prosperous trade and artistic center before World War I, had much in common with Glasgow. Because of its geographical position at the eastern end of Europe, Eastern art of all types had been a part of Viennese culture for centuries. An oriental richness of pattern and color is typical of the work of the Secession, as seen in its most famous member, the painter Gustav Klimt.

In the spirit of William Morris, the Secession declared in their magazine, *Ver Sacrum*, "We recognize no difference between high art and low art. All art is good." Designers were among the founding members, and two of them, Joseph Hoffman and Kolo Moser, started a workshop modeled on William Morris's studio and called it the Weiner Werkstatte (the Workshop of Vienna). They produced graphic arts and books, furniture, housewares, and, of course, textiles. The textile department was particularly successful, and many Hoffman and Moser fabrics are still produced today by Backhausen, the firm that started manufacturing them in 1900.

Kolo Moser's original 1899 sketch and the finished textile "Vogel Bulow." Moser's designs for the Weiner Werkstatte were strongly influenced by the Glasgow School.

PHOTOGRAPHS COURTESY THE BACKHAUSEN ARCHIVES

Josef Hoffman's original 1904 sketch and the finished textile "Zick Zack." Hoffman's textiles for the Weiner Werkstatte introduce a strongly graphic modernism that predates Art Deco and Bauhaus design.

PHOTOGRAPH COURTESY THE BACKHAUSEN ARCHIVES

The Glasgow School and the Secession were essentially apolitical. They depended on wealthy patrons and were interested in producing fine work with little regard for cost. The original Arts & Crafts political ideals of respect for honest labor and commitment to excellent but affordable craftsmanship that had inspired William Morris were of less interest to these designers than the aesthetic ideas of functionalism and purity of materials. The severe geometry of much of their work was an inspiration for Art Deco, Bauhaus, and later, modern architecture.

In the United States, the Arts & Crafts movement developed as a uniquely American blend of capitalist promotion and new-world idealism. The two main promoters of the style in the United States were Gustav Stickley (1857–1942) and Elbert Hubbard (1856–1915).

Stickley is best known as a furniture maker. He was deeply influenced by the British Arts & Crafts movement and the work of William Morris. He established his own guild of artisans, United Crafts, to produce a whole series of products for the home. He was the first home-furnishings merchant to produce a full line of textiles, furniture, lighting, and even house plans. He sold directly to the consumer and published a magazine, *The Craftsman*, to publicize his products and philosophy. With a strong belief in the value of hand labor, he also printed practical articles on such things as how to make textiles for the Craftsman interior or how to plant a useful and attractive garden.

Stickley's catalogs advertised yardage, carpets, and various simple made-up curtains that he thought appropriate for his houses. These items were not much different from what was available in any dry-goods store or catalog. However, they were always the simplest styles. He also produced stenciled and embroidered curtains, portieres, pillows, and table linens. Stickley was not much of a textile designer, and the embroideries produced by United Crafts are of a variable quality suggesting the work of several designers. The United Crafts textiles are the simplest of patterns. They are sometimes almost crude, but when they are successful, they are among the purest representation of the American Arts & Crafts style. The highly abstract natural forms make a most sophisticated composition that is both simple to manufacture and to reproduce at home. Stitching is plain and is often worked charmingly with appliqué or stenciling, which saves labor. This simplicity kept Stickley's embellished textiles affordable and served as encouragement for beginners to find fulfillment in working with their hands, two goals that much Arts & Crafts design had never achieved.

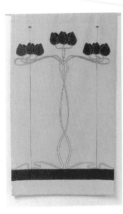

This portiere with "Seedpod" design is one of Gustav Stickley's loveliest designs, combining graphic simplicity with sophisticated lines and composition and showing American Arts & Crafts design at its best. Reproduced here by Dianne Ayres, the original portiere was offered made-to-order in a variety of colors for $20.

PHOTO COURTESY ARTS & CRAFTS PERIOD TEXTILES

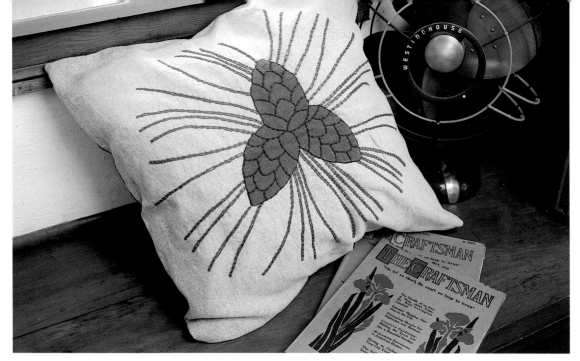

The "Pinecone" is probably Gustav Stickley's most popular textile design. This reproduction shows it as an appliqué, but he also produced it as a stencil and used a variation on runners and curtains as well. The 25-inch-square pillow, completed, was sold for $5.00. It was available as a kit for $1.75.

PHOTOGRAPH BY PHIL BARD

PHOTOGRAPH COURTESY
ARTS & CRAFTS PERIOD
TEXTILES

Embroidery Project Ideas from *The Modern Priscilla*, *Home Needlework*, and *Needlecraft*

• "Among the numerous articles which are made for gift purposes nothing is of more practical value than towels, and especially guest towels."
• "Anyone who has possessed a ball of nice twine hung in a convenient location in its own little ornamental bag has appreciated the convenience of always having it handy and wondered how one could ever do without it."
• "The pinecone is a favorite motif always, and is particularly so when used as decoration for a fragrant pine pillow—the filling whereof is not really pine at all, but the balsam fir which holds its scent almost indefinitely and may be renewed by laying the pillow on a warm radiator."
• "A dainty little embroidered clothes-hanger makes a useful, acceptable present for a child, and one which is appreciated by the mother as well."
• "A large laundry bag is something every man has need of."

Home Needlework magazine

15

Elbert Hubbard started the Roycroft Shops in 1895, modeling them after William Morris's Kelmscott Press. The name Roycroft refers to the seventeenth-century printers Samuel and Thomas Roycroft. The logo, an orb and cross, came from Cassidorius, a monk and illuminator. Hubbard's first interest was printing and publishing, but he was really the first "lifestyle" promoter. He was a master salesman and born entertainer who traveled constantly to promote his ideas, even appearing on the vaudeville circuit. He published a magazine, *The Philistine*, and many books. The most famous of these was *Little Journeys*, a series of short biographical sketches of famous and inspiring men. His writings seem rather precious today, but he was a great popularizer and was the first person to really inspire people of average means and education with Arts & Crafts ideals.

Hubbard was a determined capitalist and an admirer of big business. His tours and publications were equally intended to promote the goods made in the Roycroft Shops. The shop turned out attractive furniture, obviously inspired by William Morris, with the Roycroft logo prominently displayed. The main Roycroft contribution to textile design came through its graphics, specifically, the work of Dard Hunter, the Roycrofters' main graphic designer. Hunter's work is influenced by the Glasgow School and the Weiner Werkstatte. His lovely illustrations and marginalia were an influence on embroidery and other surface designs as published in the popular women's press.

Stickley and Hubbard were both based in the northeast: Hubbard in upstate Aurora, New York, and Stickley in New York City and New Jersey. In the American Midwest, an enormous period of growth began at the end of the nineteenth century. The uncertainties and roughness of the pioneer days were gone, and cities were becoming powerhouse centers for agricultural trade. Chicago was rebuilding after the great fire and the fields just outside most cities were filling with small houses, fulfilling the American dream of home ownership. In Illinois, Wisconsin, Iowa, and Minnesota, particularly, a new style of architecture appeared—the Prairie Style. Heavily influenced by Arts & Crafts forms but uniquely American, the Prairie Style used low horizontal silhouettes and even more abstracted and geometric shapes. The architects of the Prairie Style—George Maher, George Grant Elmslie, William Gray Purcell, and Frank Lloyd Wright, among others—often designed textiles for their interiors. They used the same surface techniques of stenciling, appliqué, and embroidery. These pieces were custom made and still represent the high end of American Arts & Crafts embroidery.

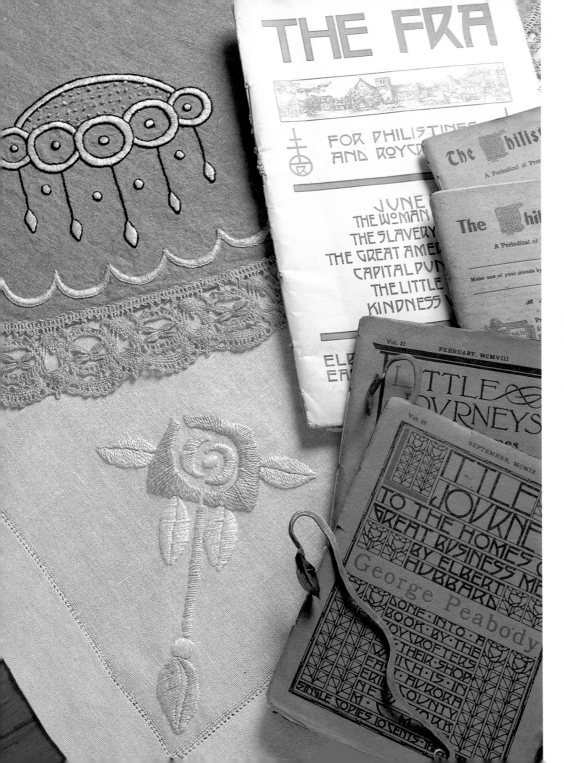

The graphic arts of the Roycrofters were an important influence for textile design. Textiles from the collection of Rosemary Kostansek, Roycroft literature from the collection of Ken Fearing.

PHOTOGRAPH BY PHIL BARD

George Washington
Maher and Louis J. Millet
(designed by), American,
1864–1926 &, Portiére
from Patten House,
cotton and silk, cut velvet
weave with appliquéd
pattern and embroidered
in silk, 1901, 80 1/8 in.
x 48 in. Restricted gift of
the Antiquarian Society,
1971.680.

PHOTOGRAPH © 1999,
THE ART INSTITUTE
OF CHICAGO.
ALL RIGHTS RESERVED.

Later, Wright also had fabrics woven to his designs. Wright and the other designers of the Prairie School made their surface design even more abstract and geometric until it was often simply a composition of squares, parallelograms, and long vertical lines.

In California, the western Arts & Crafts style was strongly influenced by the open-air lifestyle, the Spanish warmth of the old missions, and the recurring influence of Japanese design. Like the architects of the Prairie School, who also worked on the West Coast, the brothers Charles Sumner Greene and Henry Mather Greene did their most famous work for wealthy clients who could afford the elegant woodwork and fully designed interiors they preferred to create. Greene and Greene also designed needlework for their interiors that was often completed by the lady of the house.

But in this period of prosperity and expansion, most American Arts & Crafts houses were modest bungalows—affordable housing for the growing working and middle class. The curtains, portieres, table linens, and cushions used in these homes were most likely made by the homeowner. All women did everyday sewing and mending, and the sewing machine was a basic household appliance. Even rather small houses during this period may have had a small room, usually near the bedrooms or kitchen, that was the sewing room. These rooms have often left contemporary occupants wondering what this bedroom without a closet was used for.

The Art Needlework movement had created a new interest in fine sewing and embroidery, and new manufacturing techniques made available more types of thread in more colors at better prices. Thread companies were booming, and, with their advertising support, so were women's magazines like *Needlecraft* and *Home Needlework*, which were devoted entirely to fine sewing. Other magazines like *The Modern Priscilla*, *The Delineator*, and *Ladies' Home Journal* published recipes, women's fiction, and other subjects also including many needlework projects. Improved mail delivery made national advertising practical, and for the first time manufacturers sought a brand identity. With more advertising, the women's magazines became more affordable and subscriptions skyrocketed.

Frank Lloyd Wright's design 513, "Imperial Triangle," was one of his surface designs woven into fabric.

PHOTOGRAPH COURTESY
F. SCHUMACHER & CO.

The silk companies—such as Nonotuck Silk in Massachusetts, Richardson Silk of Chicago, and Belding Brothers in Michigan—particularly promoted freestyle embroidery, producing vast numbers of designs and kits. Their marketing was quite sophisticated: they worked with the magazines to offer free patterns with subscriptions, they promoted needlework clubs, and they sponsored contests. The Nonotuck Silk Company also published *Home Needlework* magazine.

The designers employed by the thread companies and the magazines were usually educated women who had learned a great deal of needlework as part of the traditional feminine education of the late nineteenth century. These women were direct descendants of the founders of the Royal Embroidery Society. At the same time, they designed for thread companies and magazines, often published their own books, and ran their own shops. They were successful entrepreneurs, making up the majority of the staff in factories and magazines. Alice Manning and Mabel Rand developed particularly sophisticated designs for *The Modern Priscilla*. Max Hagendorn's work (a rare man in the profession) was so abstract and advanced that it was usually accompanied by a written artistic justification.

Some designers were recent immigrants or first-generation citizens who brought their native needlework techniques to the American market. Magazines often featured Russian embroidery, Scandinavian hardanger, or Native American motifs. The interchange of ideas contributed to the unique American style and many of these so-called "ethnic designs" are considered Arts & Crafts by collectors today. The designers were knowledgeable about the history of their craft, including the the work of William Morris and the New Art. They were responsible for the popularization of Arts & Crafts motifs. With their many readers, these women's magazines spread the decorative style of the American Arts & Crafts movement much more widely than *The Philistine* or *The Craftsman*. Magazines and thread manufacturers rarely promoted Arts & Crafts designs as a separate category. They were producing large collections intended to appeal to a variety of tastes. Their catalogs showed traditional Colonial Revival designs mixed with Arts & Crafts motifs and popular designs such as state flags and club logos.

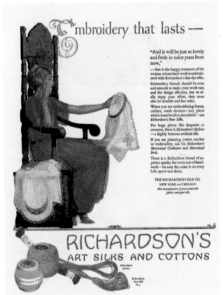

Richardson's Silk Company of Chicago was one of the larger promoters of art needlework, with an extensive catalog of designs.

At the beginning of the twentieth century, techniques were finally invented to spin fine, smooth cotton and to dye it with rich permanent colors. Companies like J. P. Coats and The Royal Society marketed their improved product aggressively, but silk was preferred for art needlework. As the price of raw silk imported from China continued to rise, the silk companies were the first to be affected by the textile recession of 1925–26. Blends of rayon and silk or 100-percent-rayon thread were sold as "artsilk" and eventually cotton replaced silk in most kits. Belding Brothers first absorbed Nonotuck and, finally, the Richardson Company became Belding-Corticelli, the only survivor of the Great Depression.

Between 1920 and 1930, most small thread companies closed. The larger ones reduced their advertising budgets, forcing most of the women's magazines out of business. Art needlework, as opposed to sewing and mending, went into a slump it did not start to recover from until the craft revival in the late 1960s.

It is particularly interesting to note the parallel between the profitability of needlework and the early and second wave of feminism in America. Although skill in sewing is often considered a cliché describing traditional womanhood, a profitable and growing needlework industry provides income and independence for women of many levels of skill and education. When it came to needlework, the social activism of the Arts & Crafts movement was particularly directed at improving the lot of women. Even mainstream magazines picked up on this and encouraged women to make their own money and work outside the home. *The Women's Home Companion* supported woman suffrage and often discussed the rights of working women. *The Modern Priscilla* and *Needlecraft* wrote of the importance of ethnicity to developing uniquely American needlework.

The Arts & Crafts movement in America combined aesthetic ideals with political activism long after it had become only a design style in Europe. In its late-twentieth-century reincarnation, this tradition continues to be committed to revitalizing old neighborhoods and promoting a simpler, more environmentally conscious lifestyle.

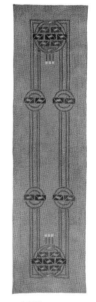

Table runner,
The Modern Priscilla,
1909.

"In the life in which I grew up, there were no girls
of fortune . . . The career of a powerful and competent woman,
as we know it today, was an unheralded dream."
—*Candace Wheeler*, 1918

IDENTIFYING THE ARTS & CRAFTS TEXTILE

"The new embroidery is common in this respect to
the oldest arts, it takes the everyday things of life, and . . .
seeks to make them beautiful as well as useful."
—*The Studio*, 1910

It is almost impossible to rigidly define American Arts & Crafts textiles.
There are several reasons for this.

First, the American Arts & Crafts movement came at the end of over
fifty years of reaction to mass-produced taste. Previous artistic styles and
aesthetic philosophies (themselves also overlapping) were strong influences on
the movement in the United States.

The strongest ideological influence was William Morris and the Arts
& Crafts movement in Great Britain. The constant editorial exhortations in
women's magazines to simplify both in decoration and in lifestyle, to take
pleasure in handiwork, and to seek both beauty and utility—all combined
with mild political liberalism—came directly from Morris.

The Aesthetic movement, represented by the work of James McNeil
Whistler, Aubrey Beardsley, and Lord Leighten, was mainly urban and
European, although noted Aesthete Oscar Wilde was enormously popular when
he toured the United States. However, the decorative style of the art and the
strong influence of Japanese forms was definitely an influence on embroidery
designs and home decoration. It is quite possible to categorize Candace
Wheeler—strait-laced daughter of abolitionists and a proud housewife—as

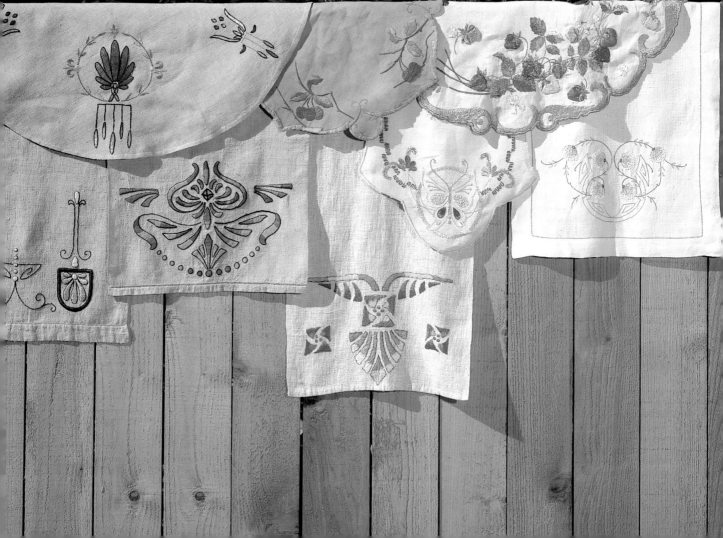

A collection of typical Arts & Crafts table runners and centerpieces. The classic piece is embroidered on coarse natural linen. Designs are from abstracted natural forms, often featuring both Art Nouveau and geometric elements. Design elements are often outlined in black. More naturalistic pieces show the influence of English art needlework. Although many pieces are now faded, American embroidery was noted for its vivid colors. Clockwise from top left: (1) from the collection of Rosemary Kostansek; (2), (3), and (5) from the collection of Tim Counts; (6) and (8) from the collection of Ken Fearing; (4) and (7) from the collection of the author.

PHOTOGRAPH BY PHIL BARD

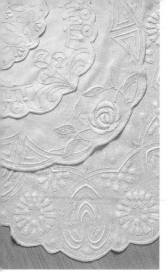

White work is not considered typical for Arts & Crafts textiles. However, the abstract graphics and the use of line in these embroidered centerpieces clearly place them in the Arts & Crafts style. Centerpieces 1, 2, and 4 from the collection of Rosemary Kostansek, 3 from the collection of the author.

PHOTOGRAPH BY
PHIL BARD

an Aesthete. She admired Lord Leighton, visited his studio, made a great study of Japanese art, and wrote of purity and beauty in a remarkably Aesthetic style.

The Aesthetic movement is the direct ancestor of the New Art of Glasgow and the Wiener Werkstatte, as well as Art Nouveau. Although Mackintosh, Hoffman, and Moser all expressed admiration for William Morris, they pursued beauty rather than functionalism. They were more interested in breaking with the recent past than studying medieval forms. Their work tended to be more concerned with surface design. While the furniture of the American Arts & Crafts movement refers directly back to Morris and Ruskin in its rough functionalism, the embroidery, as a form of surface design, quite naturally shows strong influences from the Aesthetics movement and its descendants.

Second, the designers of art needlework were neither particularly ideological nor at all stylistically pure. They were quite happy to mix curvilinear Art Nouveau forms with the squares and geometrics of New Art. They were also willing to use nontraditional color schemes influenced by their own ethnic heritage, personal taste, or, no doubt, what the thread manufacturers wanted to promote.

The designers were generally unknown or of modest fame in needlework circles and not strongly associated with any school of design. If Gustav Stickley used a bright-colored Native American motif or an Art Nouveau switchback curve, it was accepted as Arts & Crafts because it was a Stickley. If an unknown designer for *The Modern Priscilla* did the same thing, we are less certain.

Third, embroidery kits and designs, the main source for Arts & Crafts textiles, were marketed mainly as part of a huge national embroidery business, much larger than the more educated market for specifically Arts & Crafts items. While followers of Hubbard and Stickley would certainly be interested in such things as Bungalow pillow designs featured in *The Modern Priscilla*, the designs had to appeal to the larger customer base of women's magazines. If customers were interested in white work instead of natural colors, and wanted tatted or lace edging on their runners instead of simple hems, the magazines would show Arts & Crafts embroidery on white with lace edging.

In addition, because the needlework market was so large, its marketing was directed at people with average or beginner skills. While designers might be influenced by Art Nouveau and Viennese styles, they could not allow an interest in overly refined beauty or exotic techniques to frighten off new cus-

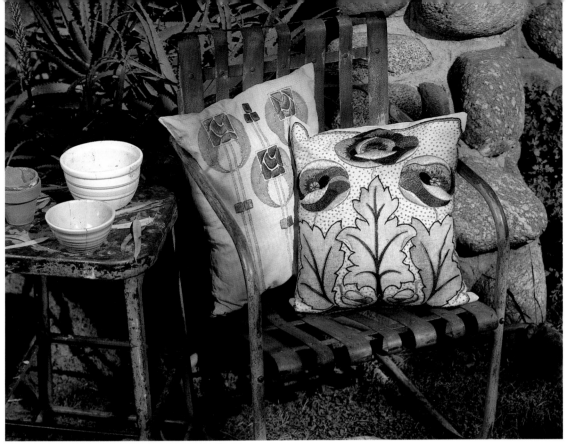

These pillows are excellent examples of the classic Arts & Crafts technique of combining stenciling and embroidery. Compare the faded vintage "American Beauty" pillow by H. E. Verran on the left with the reproduction by Arts & Crafts Period Textiles on page 86.

PHOTOGRAPH BY PHIL BARD

tomers who possessed minimal skills. They kept many of their projects fairly simple, often showing designs in outline work or with stenciling.

In fact, it may be that American Arts & Crafts textiles are the single complete synthesis of the British Arts & Crafts movement—whose emphasis is on usefulness, simplicity, and rich surface design—and the strong linear style of the New Art and the Weiner Werkstatte. These nationally advertised embroidery kits and patterns were also the only product of Arts & Crafts design that actually realized the goal embraced by everyone from the time of William Morris, which was delivering a new aesthetic and an appreciation of handwork to the general population.

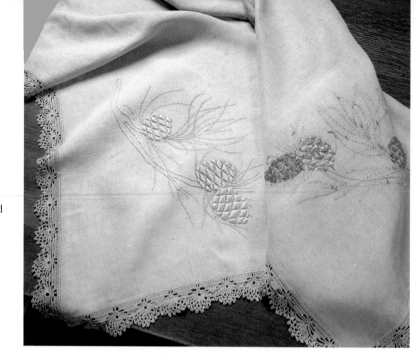

Looking at the wrong side of a vintage textile often reveals a richer color scheme. Notice how much stronger the browns and greens are on the back of this centerpiece embroidered with pinecones. Severe fading on the textile face affects its value. From the collection of Rosemary Kostansek.

PHOTOGRAPH BY
PHIL BARD

An embroidered laundry bag was considered a practical gift for a man. This example has remarkably unfaded embroidery. From the collection of the author.

PHOTOGRAPH BY
PHIL BARD

It is still possible to list some characteristics of Arts & Crafts textiles, with the caveat that many valuable and attractive pieces will not meet all these requirements. The embroidery is most likely done on a base of rough natural fabric. The classic choice is unbleached natural linen. Finishing is as simple as possible. Pillows are seamed without ruffles or cording. Flat pieces such as runners have a pull-thread hemstitch, an embroidered edge, or a simple blind hem. Tatting is acceptable if it is very simple.

The embroidery is chromatic in rich, deep colors. Dark red, forest green, golden brown, terra-cotta, loden green, rust, dark brown, teal blue, burgundy, sage, and gold are typical. White, pink, French blue, or navy blue would be unusual. Motifs are often outlined in black. The work is done entirely in satin stitch, darning stitch, and outline, or stem stitch with possibly French knots as accents. The thread for a vintage piece is silk floss, an imitation rayon silk, or perle cotton.

The design itself is an abstract version of a natural form, preferably a plant or insect. The more abstract, the more comfortable we are that the piece is Arts & Crafts. If the design is so geometric and abstract that we cannot recognize the orginal inspiration, it is definitely Arts & Crafts. On the other hand, if the design is organic and quite recognizable but clearly influenced by William Morris, it can also be considered Arts & Crafts.

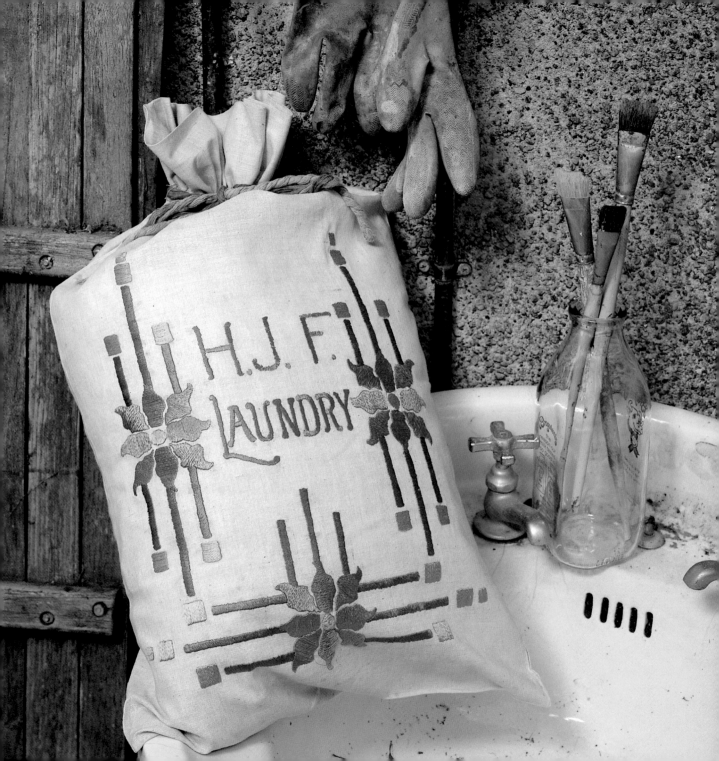

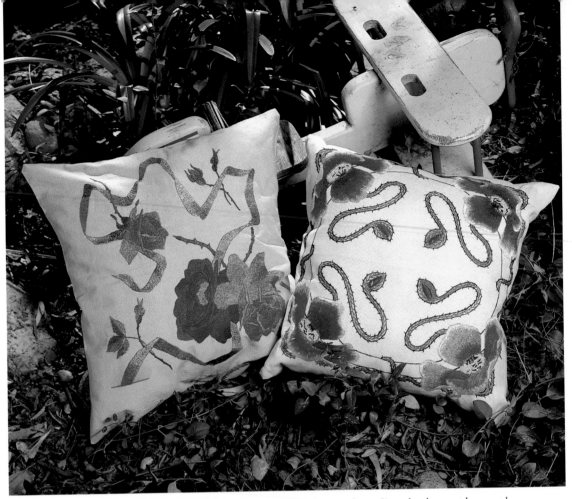

It is possible to find embroidered pillow tops that have not been made up. Since they have not been used, they are often in good condition. The pillow on the left is a Richardson kit: right, from the collection of Tim Counts; left, from the collection of the author.

PHOTOGRAPH BY PHIL BARD

The best way to become comfortable with this fluid definition is to develop what art historians call "connoisseurship" by studying the style in depth until you have an immediate and reliable certainty that something meets your definition. In retrospect, you may articulate your certainty, but your first reaction will be convincing, immediate, and nonverbal.

In addition, don't forget that the Arts & Crafts movement represents a philosophy as well as a design aesthetic. It is worth considering if a piece is true to

this philosophy. Is the design appropriate to its use, and in fact, is the object useful? It is not so difficult to make something beautiful if plenty of time and money are available. Has the designer made an effort to create an attractive piece that an ordinary person might purchase? Do not confuse craftsmanship with technical bravado. Remember John Ruskin and his respect for the roughness of the handmade. An Arts & Crafts textile should be made with care and respect for the material, but it should not be a tour de force of fancy or overelaborate stitching.

Collectors have tended to look down on early-twentieth-century textiles. The very popularity of art needlework resulted in so many indifferent designs, frivolous projects, and plain bad sewing that high-quality work was also ignored. Many collectors still prefer original work with a known provenance. For a long time, this kept Arts & Crafts textiles affordable. But as collectors have gained an appreciation of the philosophical context of the work and of the generally high level of design, prices have increased. It is still possible, however, to put together a collection with a modest investment.

Because the women who finished these kits possessed a wide range of skill, the quality of finish for several examples of the same design may vary widely. This means that the collector needs to acquire at least a basic knowledge of needlework.

Designs for pillows from *The Embroidery Book*, 1914.

A comfortable familiarity with the Arts & Crafts style is necessary unless only pieces of the most rigid and narrowly defined style are purchased. The only way to achieve this is to look at as many Arts & Crafts textiles as possible by visiting antiques shows, museums, and libraries. Magazines and picture books are also useful, although it is important to see and, if possible, touch actual pieces.

Embroideries from well-known manufacturers were stamped with the company name. However, it may have been trimmed off in finishing. A piece may have been made from a transferred design and have no mark. Most collectors look for old needlework catalogs and copies of women's magazines of the period to familiarize themselves in greater detail with the work of various manufacturers and designers. It can be particularly gratifying to find the original illustrated instructions for a textile. Many libraries have collections of period magazines. Serious collectors may purchase items to decorate their house, to create a research archive, as an investment, or for any number of reasons, but they all emphasize the pleasure that they get from studying the period and researching and hunting for pieces.

Arts & Crafts Design at the Beginning of the Century
The Prang Educational Company's Text Books of Art Education

The Prang series on art education, published in 1905, was written in conference with art teachers from across the country. They sought to create a system of art education for children using what they called "balance, rhythm and harmony." This was defined at length with exercises provided for the young artist. The books valued drawing, painting, woodworking, and pottery. They often quoted Ruskin and used Mission furniture and Arts & Crafts graphics (as opposed to Victorian furniture and wallpaper) as examples of good design. This may seem quite in contradiction to the original Arts & Crafts idea of eliminating externally imposed canons of design.

• Drawings are not precisely like the parts from which they are taken, as a designer may always simplify what he actually sees in nature or change it to suit his purposes. The leaf is plainly simplified. That is, all irregularities have been omitted and the sides are balanced on an axis.

• A sketch that shows the actual appearance of a plant or animal is called naturalistic. When we make certain changes in order to adapt a motif to some use, such as a border or frame, we say that such a treatment is decorative. A purely naturalistic treatment should not be used in decoration.

• A design is an idea or thought expressed in an orderly way. In planning a decoration, a careless or accidental repetition of a shape might result in a very poor border because it lacks order and a plan.

• Nature uses rhythms of grayed or subdued colors in much greater abundance than she uses rhythms of bright colors. In sunset skies and the plummage of tropical birds, we sometimes find beautiful color in full intensity, but these examples are rare when compared to the wealth of grayed color we see all about us. The designer, the house furnisher, the milliner, and the dressmaker may follow this suggestion from nature, using a good amount of grayed color in their color schemes.

• Keep a notebook of the colors you find in nature. Look for beautiful color schemes and remember that, for practical uses, grayed or subdued color is safer than a scheme of brilliant hues. Learn to see the beauty of these soft refined tones.

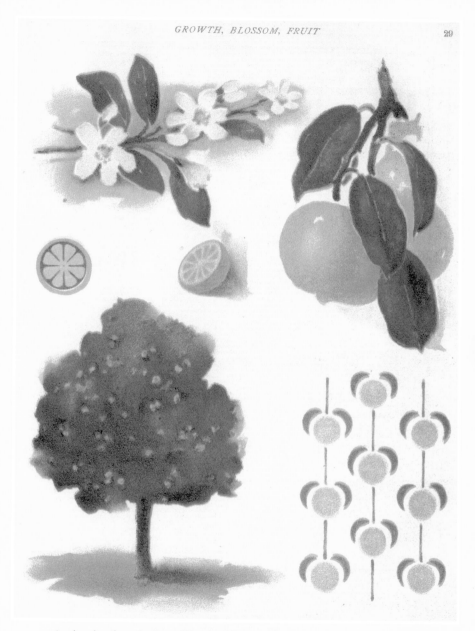

A color plate from the *Prang Educational Company Text Books of Art Education, Book IV.*
A classic illustration of how a naturalistic design source might be abstracted and used as a
fabric repeat or graphic motif, typical of Arts & Crafts design.

ROSEMARY KOSTANSEK
Building a Collection to Live With

Rosemary Kostansek first came upon the Arts & Crafts movement when she was an art major in college. She saw pictures of the architectural work of Charles Rennie Mackintosh and Frank Lloyd Wright and loved it, but she never associated it with textiles. Her interest in embroidery was a separate pleasure that she had pursued since childhood but, as a busy student, had put aside. After college, Rosemary started stitching again, becoming an active member of The Embroiders' Guild of America and Friends of Counted Embroidery, opening her own shop in 1979 with two of her partners.

Kostansek and her husband, Ed, enjoy antiquing, so she began looking for textiles and old needlework magazines. Because most of her furniture was inherited Victorian, she first purchased textiles from that era. By chance, her husband inherited an Arts & Crafts desk, and, while looking for information about this attractive style, they stumbled upon a tiny advertisement for the Grove Park Inn Arts & Crafts Conference in Asheville, North Carolina. They attended the conference and fell in love with the oak furniture, the pottery with the beautiful glazes, and, of course, the textiles.

Kostansek, who lives in eastern Pennsylvania, became a founding member of the Textile Collective at Craftsman Farms, together with Gustav Stickley's New Jersey home, which is now a museum. She works on reproducing textiles for display at the farm and has contributed several pieces for the exhibit *Time of Transition: Textiles of the Arts & Crafts Period, 1900–1915.* In the Master Craftsman program of The Embroidery Guild, using her area of special expertise, she has translated Arts & Crafts designs into beautiful original pieces stitched in counted work. She continues searching antiques shops for pieces for her collection and for needlework ephemera to add to her knowledge of the period.

Quality Arts & Crafts textiles are still a good value, according to Kostansek. Outside of the well-known antiques shows, many dealers are more interested in furniture and do not appreciate fabric. She is often able to find pieces of handmade lace mixed with inexpensive machine-made goods or Arts & Crafts pieces piled with embroidery that is only a few decades old.

Since Kostansek enjoys displaying her collection, she looks for pieces that will work with her furniture. She seeks the highest quality pieces that show the finest stitching and are sturdy enough to be used. She will only buy a

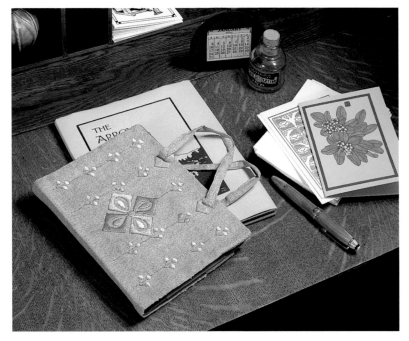

Embroidered book cover
from the collection of
Rosemary Kostansek.

PHOTOGRAPH BY
PHIL BARD

damaged piece if it is particularly unusual, and then, only as a reference piece, not for display.

After finding a textile she likes, Kostansek first checks the back. A good piece will not be faded and will show the same coloring on the front and the back. She also looks for thread ends, frays, and bad knots on the back of the embroidery. This is a sign of less-skillful work that may not stand up to use. She inspects the face of the textile for loose stitching. Since most pieces were made from stamped kits, she looks for stitching that fully covers printed lines. She will not buy a piece for display if it is stained or contains holes.

Repairing a textile is not important to Kostansek. Most collectors think that no repairs should be made that cannot be undone to return the piece to its original condition. Kostansek goes a step further. She believes that the addition of contemporary threads and needlework diminish a piece's value. She points out a pillow top with a holly pattern and a small unfinished section. She says, "I know that I could finish that so that no one would know." But she feels it would violate the history of the piece. Perhaps the seamstress ran out of thread or, since it was never made into a finished pillow, set it aside and forgot it for some reason. This is, no doubt, the reason that it is in excellent condition—

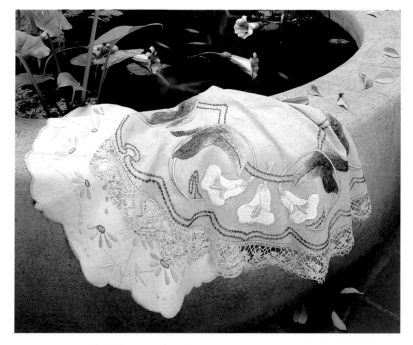

Embroidered centerpieces
from the collection of
Rosemary Kostansek.
PHOTOGRAPH BY
PHIL BARD

it was never used. If she completed the pillow top, Kostansek would preclude this sort of rewarding speculation.

With embroideries she believes are colorfast, Kostansek will gently clean them but finds that art silk is likely to bleed in water. She rotates her collection frequently to minimize exposure to light and dust and is careful about displaying pieces in places where they might be spilled on. She rolls most of her pieces for storage and re-folds her larger pieces several times a year.

One thing Kostansek recommends is that beginning collectors spend a good amount of time familiarizing themselves with the Arts & Crafts style. She urges them to look at furniture, pottery, and lighting as well as textiles. A thorough knowledge of motifs—Kostansek searches for dragonflies—and classic stitches will give the beginner confidence in collecting in an area of decorative arts that is little documented and often ambiguous.

Kostansek has a bone to pick with Gustav Stickley. She does not entirely approve of his choice of Craftsman Canvas (a blend of jute and flax) for so many of his textiles. She believes that it is not of high enough quality for skilled embroidery and it is difficult for the novice embroiderer to learn from it.

A research piece from the collection of Rosemary Kostansek. This partially embroidered centerpiece still shows its pattern number. The intricately curved edge was intended to be finished with a heavy buttonhole stitch. Often, however, it would be cut in a simple circle and edged with lace.

PHOTOGRAPH BY
PHIL BARD

The Textile Collective at Craftsman Farms

According to their brochure, the Textile Collective at Craftsman Farms is a unique organization devoted to "benefiting Craftsman Farms and renewing interest and promoting an understanding of the textiles associated with the Arts & Crafts Movement." Beth Ann McPherson, curator of interpretation, produces a lecture series three times a year. Such events usually include evening lectures and a hands-on workshop. The collective also meets monthly to work on needlework projects suitable for both beginners and experienced seamstresses. Working from photos of the originals, a current project involves a pair of curtains for the Paul Fiore memorial room—formerly the girls' bedroom. Although Craftsman Farms is only open April first through November fifteenth and over the holiday season, the Textile Collective meets throughout the year.

For information, contact Craftsman Farms at 2352 Rt.10-W, Box 5, Morris Plains, NJ 07950, (973) 540-1165.

KEN FEARING
Imagining the Person Behind the Work

Ken Fearing is an avid collector of many things: antique silver, old photographs, china, folk art, Arts & Crafts furniture and accessories. Having grown up in the San Fernando Valley of Los Angeles County, he developed an early love for rummaging for antiques. In his younger days, the valley was sparsely settled and there was little to do except ride his bicycle. One of his favorite destinations was an antiques shop, which he visited regularly, always buying something.

Later, at Macalester College in Saint Paul, Minnesota, Fearing took an inspiring course on the Arts & Crafts movement. He fell in love with the style but couldn't afford to start a collection on a student budget.

Like many collectors, Fearing's first Arts & Crafts purchase was a house. A friend who was an architect had pointed out the early-twentieth-century bungalows and four-squares that were available at low prices and included wonderful period detail. Fearing's house was a classic four-square featuring an unusual living room with a breathtaking tile fireplace. He knew it needed the "right" furniture.

Fearing's first furniture purchase was an Arts & Crafts rocking chair whose maker was unknown. He has since sold it. His philosophy of collecting is to buy what one can afford and gradually trade up as expertise and budgets grow. Fearing enjoys perusing his extensive collection of Arts & Crafts ephemera—books, old furniture catalogs, and advertising. With long evenings of window shopping, he has memorized the catalogs of United Crafts, the Roycrofters, and other companies and is thus able to snap up bargains at estate sales and rural antiques shops. Fearing says that the time finally came when he had upgraded his furniture to a point where improving on any piece would be a major financial commitment on the order of buying an automobile. He loved the furniture, but the rigorous standards that came with increased value (the search for the carefully preserved label, the original finish, the correct nail head) had taken some of the spontaneity out of collecting. On his long collecting expeditions in the rural Midwest, he began to search for Arts & Crafts accessories and to built his textile collection.

Aware of the fact that most textiles were made from kits by amateurs, Fearing feels that the difference in quality makes the collecting more fun. He says that with textiles he likes to feel the personality behind the work and actually seeks out pieces with some humorous sign of the maker's personality,

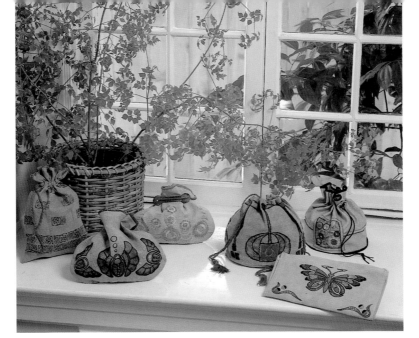

Bags were popular embroidery projects. The stenciled bag on the far left is from the estate of L. G. Stickley. The two flat-bottomed bags on the right are intended to hold starched collars. From the collection of Ken Fearing.

PHOTOGRAPH BY
PHIL BARD

such as an unusual and obvious scrap fabric for a pillow back, odd cording or recycled buttons on a work bag, or an indication in the stitching that one person—perhaps a young girl—started a project, but someone else—maybe her mother—finished it.

One thing Fearing notes is that most quality Arts & Crafts furniture, such as the work of United Crafts, was fairly expensive even when new. Textiles—particularly kits—were inexpensive and might be the only Arts & Crafts pieces a homeowner could afford. Not always part of a deliberate Arts & Crafts collection, these embroidered cushions, accessories, and table linens often turn up at modest prices at estate sales and small antiques shops.

Many of Fearing's favorite pieces were chosen for the fabric itself. He has several pieces that he believes may have been woven, as well as embellished, by the maker. He will sometimes purchase a poor design if he likes the hand of the fabric. His favorite piece is a small bag, or reticule, with an unusually delicate pinecone stencil. On the occasion of purchasing it, he had broken his usual rule of buying bargains in out-of-the-way places. He purchased this particular piece from a well-known dealer at a large urban antiques show. Part of the charm of the piece was its history: it was from the estate of L. G. Stickley. Documentation from a reputable dealer obviously increased the value of the piece. Fearing likes to speculate that the bag was a development project or a sample that for some reason was never produced.

Since he is a frequent purchaser of neglected textiles, Fearing almost always washes them by hand in cool water with mild soap. He says the rinse water is usually filthy, so it's worth the risk. The only bad experience he's had was when he washed a hand-painted pillow without testing it and the color faded badly.

Fearing uses all his textiles—nothing is stored away. He proudly notes that he uses everything for the purpose for which it was originally intended, except a clothespin bag. He has no clothespins.

TIMOTHY HANSEN AND DIANNE AYRES
Building a Research Collection

Cover of *The Use of the Plant in Decorative Design, for High Schools*, by Lawrence & Sheldon, 1912. Period design theory and aesthetics from the collection of Timothy Hansen and Dianne Ayres.

PHOTOGRAPH COURTESY ARTS & CRAFTS PERIOD TEXTILES

Color plate from *Applied Art*, by Pedro Lemos, 1920. Lemos was a prolific writer on arts education and crafts.

PHOTOGRAPH COURTESY ARTS & CRAFTS PERIOD TEXTILES

Timothy Hansen and Dianne Ayres are husband and wife collectors who, appropriately enough, met at a fabric store. Ayres was doing custom sewing and Hansen was already a collector of Arts & Crafts pottery and an aficionado of the movement. The first textile they purchased together was an unusually embossed and appliquéd leather piece for which they remember paying fifteen dollars. Together, they decided to concentrate on building a complete collection of Arts & Crafts textiles. Although they use some pieces at home, most of the collection is stored at their studio and is used as a reference for their business—Arts & Crafts Period Textiles. They manage to keep storage space to barely one step ahead of the growing number of pieces crowding the studio. They are able to keep most pieces lying flat in drawers lined with washed muslin. Only the very large pieces are rolled. Ayres confesses that some pieces are stacked in suitcases.

They rarely wash their textiles, and do so only if they are certain that a spot is removable or is a fungus that may continue to damage a piece. They do not use their really important pieces at home, and they are careful to keep displayed pieces out of the sun.

Ayres and Hansen keep their paper goods in files, with pieces that are particularly fragile encased in plastic. They have a large collection of women's magazines and catalogs as well as books on the aesthetics and style in which Hansen is particularly interested. He has begun to make a computer database of his library but says he finds things mainly by "knowing where they are." Ayres points out that searching through the collection refreshes her appreciation of the work and is always inspiring.

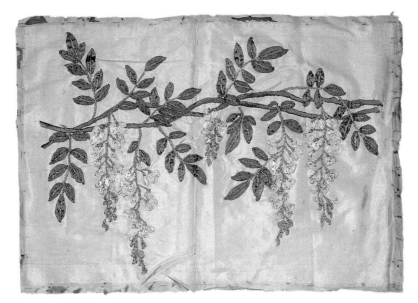

Unusual ribbon work embroidery panel from the collection of Timothy Hansen and Dianne Ayres.

PHOTO COURTESY
ARTS & CRAFTS PERIOD
TEXTILES

Ayres and Hansen's collection is an exceedingly valuable resource, but they say they would be happy to see it dispersed back to the public where it could be more accessible and useful than it might be in a museum. They feel that most museums in *this* country do not value things made by ordinary people and do not think of themselves as research libraries, as do museums in Europe.

In addition to the classic designs, Hansen and Ayres find the less-stereo-typical Arts & Crafts textiles to be more interesting. Although they continue to look for labeled pieces from known companies, they prefer original pieces that have strong design and unusual color combinations or embroidery on uncommon base fabrics rather than those made from kits. They also search for rare curtain panels, especially printed sheers, appliqué (as opposed to fully embroidered or embroidered with stenciling), and Arts & Crafts batik.

Hansen looks for life-cycle designs, conventionalized motifs illustrating the seed, buds, and flowers of plants in stylized form. Ayres likes white work and pastel embroidery with unusual colors. She points out that these were usually used in bedrooms.

After years of looking at thousands of textiles, Hansen and Ayres reject rigid definitions of the Arts & Crafts style. "If you know why it was made, and who made it, it doesn't add much to say that it is 'Arts & Crafts,'" says Timothy.

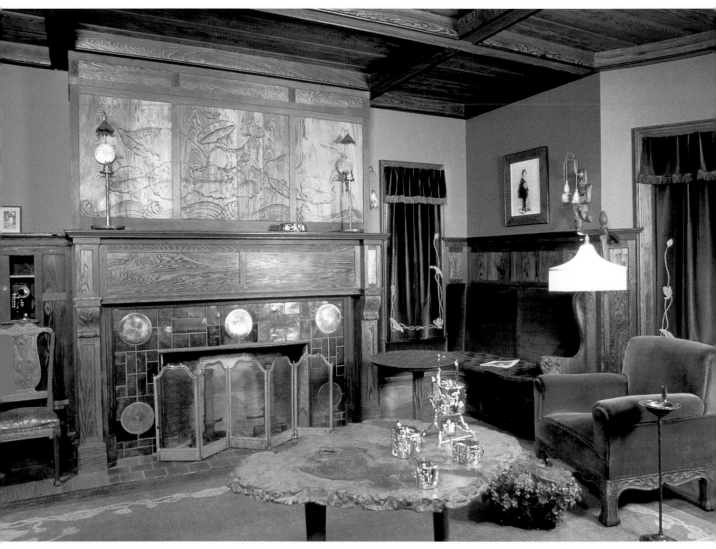

Living room from the Prindle House, Duluth, Minnesota, 1905, installed at the Minneapolis Institute of Fine Arts, with textiles designed by John Bradstreet, popular Minneapolis designer.

PHOTO COURTESY THE MINNEAPOLIS INSTITUTE OF FINE ARTS

Textiles in the Arts & Crafts House

"What are the elements that make a house attractive?
The answer is always the same—Comfort and Hospitality."
—*Keith's Magazine*, July 1915

Before the Industrial Revolution, interior decoration was reserved for the very wealthy. Certainly, people of modest means have always tried to make their homes comfortable and attractive. With the smallest bit of extra money or time, they would use decorative painting, woodworking skills, and needlework to improve the appearance of simple houses. However, the investment of time and money to coordinate draperies, upholstery, and suites of furniture, all fully accessorized with cushions, lamps, framed pictures, china, and glassware, was not possible until mass production made these things affordable and gave women, particularly, the leisure time to purchase or make such items. The result was the overwhelming, overstuffed Victorian interior, with three layers of elaborate draperies on windows, horizontal and vertical surfaces covered with useless objects, and a dizzying mixture of pattern and texture.

The Arts & Crafts movement began as a direct reaction to uncomfortable and elaborate interiors. William Morris's house, Kelmscott Manor, was considered bare when he built and furnished it in medieval simplicity. Today, it looks like a normal comfortable home. Later interiors of the Aesthetics movement, however, often seem just as cluttered as High Victorian interiors, although slightly more relaxed and comfortable. The stark, pure rooms designed by

Charles Rennie Mackintosh and the Weiner Werkstatte, while breathtaking, must have been awfully difficult to maintain. These rooms were clearly for the wealthy, who could afford to keep them immaculate.

The genius of the American Arts & Crafts movement was to create a type of house that, in its purest original form, served the middle and working classes. The four-squares and bungalows, whose floor plans filled the pages of *The Craftsman* and *Keith's Magazine*, were not watered-down imitations of grander houses. Their open floor plans, practical kitchens, and space-saving built-ins accommodate the realities of twentieth-century life as much now as then.

The proponents of the style worked hard to show homeowners a new and simpler way to furnish their rooms. After all, they were usually selling furniture, paint, and accessories. Needlework and shelter magazines featured many articles on decor that were often contradictory and full of arbitrary rules. However, they consistently urged comfort, simplicity, and easy maintenance. Now these things seem so basic that we may forget how revolutionary they were after the excesses of the nineteenth century.

Advice on furnishing a room usually centered around decor that made the room comfortable for its function. For example, it was considered important that bedrooms and nurseries be bright and hygienic. The word *hygiene* referred not only to cleanliness but also to a feeling of airiness and purity. It also provided protection from infectious diseases like tuberculosis, which terrified everyone before the use of antibiotics. Previous to 1910, bedroom woodwork was almost always painted because painted surfaces were considered easier to keep clean. Brass beds were thought to be more sanitary than wood in the nineteenth century, but by 1910, they were considered old-fashioned. The clutter of the Victorian bedroom, with its layered drapes, bed curtains, and multiple pillows, was eliminated. Instead, bedrooms were furnished simply and almost severely with a spread and a single pillow or bolster. The bedspread might be embroidered or stenciled, but patchwork quilts were less often seen, except occasionally in children's rooms. The curtains were also made as simple as possible, often with only one layer of light fabric such as batiste or linen.

Naturally, cleanliness and light seemed even more important for a nursery, and, apparently, children's rooms were often quite stark. *Keith's Magazine* urged parents to consider pastel colors in place of white, or to relieve the bright walls with stenciling or wallpaper friezes. Washable cotton rugs or linoleum were recommended for floors. Curtains were to be simple and light, with fabric heavy enough to shade the room for naps. Parents were urged to buy special,

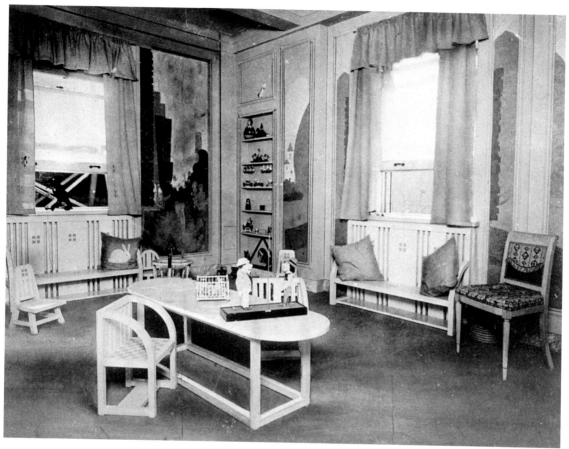

A particularly charming nursery from *Keith's Magazine*. The color scheme
is described as mainly blue and white. The custom-made furniture, in child-sized
proportions, is stenciled in blue squares, which are also repeated on the curtains.
The floor is covered in quilted denim and the mural shows scenes from
nursery rhymes. Note the appliquéd rabbit pillow on the rear bench.

appropriately sized furniture and to build the children their own window seats,
including cushions for reading, with space underneath for storing toys. A
thoughtful suggestion was to access the storage space at the front rather than
the top. It would be easier for children to use, and they would not be as likely
to drop the lid on their heads.

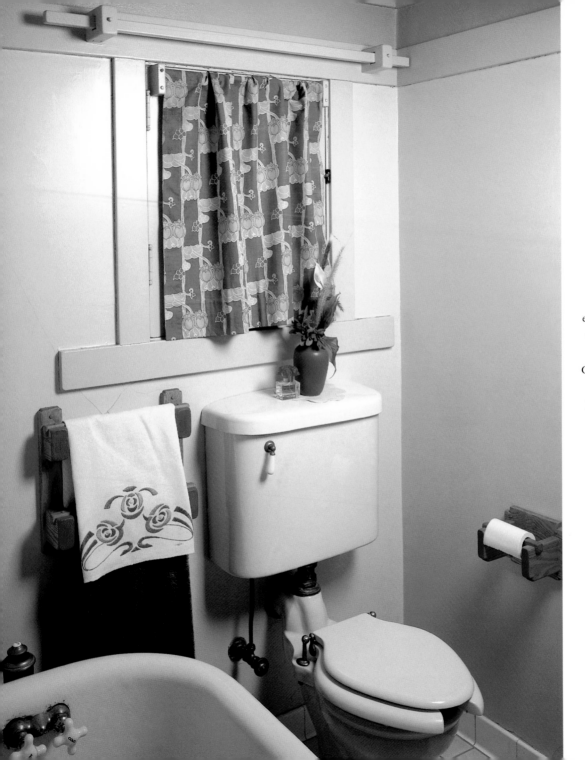

Colorful fabrics and embroidery can brighten the typical austere Arts & Crafts bathroom. Curtains from the collection of Rosemary Kostansek; textile from the collection of Ken Fearing.

PHOTOGRAPH BY
PHIL BARD

Kitchens usually had painted woodwork and were without curtains. For the sake of privacy, a simple curtain at the bottom half of the window was recommended. The ideal kitchen was a clean, functional workplace, not a room for lounging. Magazines of the period recommended a breakfast room, or at least a breakfast nook, even if it was just a corner in the kitchen. The breakfast nook might include light curtains, a few cushions, and a runner on the table.

Bathrooms were also made as simple as possible. Often, windows had frosted glass so they would not require curtains. If a curtain was necessary, it was plain. Showers were becoming more popular and were considered hygienic. The shower curtain was made of sturdy canvas and was water repellent due to its tight weave. It was strictly functional.

There was a great deal of discussion about the appropriate decor for the porch. Careful distinction was made between the porch that sheltered the front door (often called a piazza or portico) and the family porch, which was intended to be private and was usually placed at the side of the house or, if at the front, was separate from the main entrance. The family porch served as a warm-weather alternative to the living and dining rooms. It was elaborately furnished with rugs, cushioned furniture, a dining table, and shades or awnings. The textiles and furniture were light enough to be easily moved in bad weather, or to be put away for the winter, but strong enough to stand a little moisture and sunlight.

Porch rugs were made of hemp or straw, often with a Japanese motif. Washable cotton rag rugs were also practical. Outdoor furniture was made of rush, bamboo, or hickory, and these sturdy materials were much more comfortable with plenty of cushions. *The Modern Priscilla* recommended avoiding silk and velvet, instead using simpler appliqué and stenciling on linen, denim, or cretonne (a slightly ribbed cotton) for porch cushions. Motifs should reinforce the relaxed outdoor environment, featuring flowers, birds, and the ever-popular pinecone.

A south- or west-facing porch might receive a lot of sun. To be comfortable, it usually had awnings. Green or green-and-white-striped were considered the most refreshing colors. Some porches had large rolled shades in green or natural canvas or straw, but these were more awkward to use than awnings and often got caught in the wind.

The living and dining rooms and reception hall (if the house had one) were the rooms in which textiles were used most to create a welcoming warmth. Everyone understood that public rooms were for demonstrating the family's

A breakfast room with the recommended sunny and pleasant outlook.

The sheer curtains are mounted on the casement window frames so that they open into the room with the windows.
Keith's Magazine

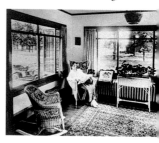

A comfortable porch furnished with cushioned wicker and a Turkish rug.

The pillows on the radiator might be stuffed with balsam to release a pleasant scent as they warm.
Keith's Magazine

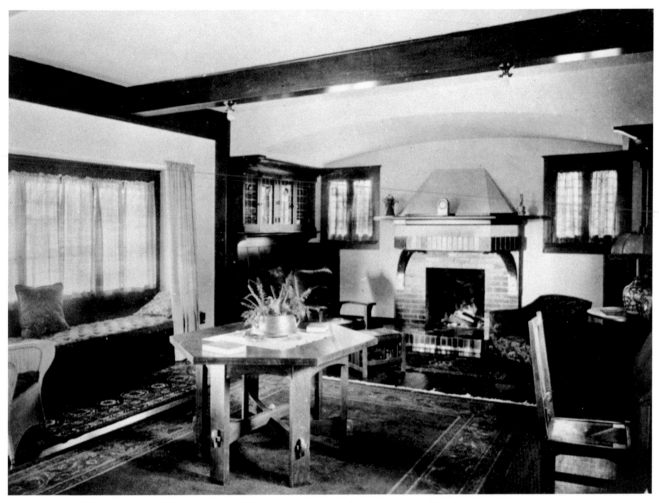

Living room from *Keith's Magazine* showing bordered carpet, table with runner, and cushioned window seat. Note drapery mounted outside window seat.

taste and prosperity. They were on show, so this was where the finest embroidery was to be displayed. However, magazines emphasized over and over that the living room was also the center for family gatherings. The dining room was the site of the important daily family dinner. The idea was to have an unpretentious rather than an elegant mood. The Arts & Crafts desire for simplicity did not mean starkness. It meant comfort. Spindly chairs and fragile knickknacks were to be banished. Furniture was to be made comfortable with

cushions. Surfaces were protected with fabric so they could be maintained in good order. The inglenook, or cozy corner, with built-in benches beneath a window or surrounding the fireplace, embodied this ideal of a relaxed home life and often dominated the living room. It was intended to encourage gathering around the home fires and was often quite crowded with pillows for lounging. This move toward comfort, however studied, was a significant change from the formal parlors seen even in small nineteenth-century houses, which included rooms that were closed off and unused, unless someone important came to visit.

Public rooms in houses always had curtains. Even in a fairly severe interior, it was not unusual to see windows with inside-mounted roller shades, sheer curtains, and heavier draperies, all protected by an exterior awning. Magazines urged homeowners to eliminate some of this fabric, but old habits died hard, and, in fact, each of these elements had its function.

Shades protected curtains and other textiles and woodwork from sun damage. Textile dyes and wood stains were more fragile than they are now, and they could fade badly in only one season if left unprotected. At the beginning of this century, products improved and sun protection became somewhat less important, but today this is still an important reason to have window coverings. Direct sunlight fades wood floors, furniture, and carpets, as well as many fabrics, especially those imported from India or China, which have unstable dyes.

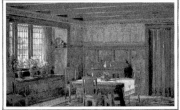

Arts & Crafts interior from a Sherwin Williams advertisement showing embroidered textiles and stenciling, 1910

A darker room was also a cooler room, and in the time before air-conditioning, rooms were kept shaded when not in use during hot summer months. Sheer curtains filtered direct sunlight and provided privacy during the day. In the evening with light behind them, they were transparent and the heavier over-curtains would be closed. These heavier curtains also provided insulation in colder climates.

Curtains were usually changed during spring cleaning. Heavy velvet curtains were replaced with lighter curtains in something like flowered cretonne. Floral prints on a black background were considered particularly appropriate for an Arts & Crafts room. An ambitious housewife might also cover the furniture with slipcovers made of a lighter fabric. The habit of scouring the house in the spring was necessary as long as houses were heated with coal, which created a great deal of black soot during the winter. In the early part of the twentieth century, steam heat became popular and, as spring cleaning became less necessary, the tradition of changing the decor with the seasons died out.

This vintage velour
portiere is woven to be
the same on each side
and would never be
used in a window.
From the collection
of Tim Counts.

PHOTOGRAPH BY
PHIL BARD

Portieres (heavy curtains designed to be hung in doorways) served a similar purpose. They could be closed for privacy and also provided insulation. In the open floor plans of many Arts & Crafts houses, portieres were a more practical solution than large heavy doors used to close off rooms for efficient heating. In small bungalows, an open door took up needed space and portieres were considerably less expensive. Because they were out of the way of direct sunlight, portieres were more lavishly decorated than curtains. This meant that they were more likely to survive. Fine examples can still be found in museums and occasionally are for sale.

The Modern Priscilla suggests making portieres from embroidered bed covers or tablecloths: fold the cover over at the top to get the correct length, making a sort of self-valance, and hang with rings or make a rod pocket at the fold.

Folding screens were a freestanding, portable way to divide rooms. In the absence of a pantry, a screen was used in a dining room to conceal the chaos behind the swinging door in the kitchen. It was able to create a private dressing area in a bedroom or provide some privacy for a sick child in a shared nursery. Folding screens could be made of almost any material that was strong enough to stand but not too heavy to move, such as solid wood, bamboo and cane, or metal. The least expensive screen was a three-hinged wooden frame with fabric panels, flat or gathered, tacked to the frame or attached top and bottom with rods fitted into the frame. Magazines often featured special stencil or embroidery designs for these screen panels.

Attractive hardwood floors, often with simple parquetry borders, were an important feature of Arts & Crafts houses. This was a change from the nineteenth century, when many homes were built with rough pine floors that were covered with patterned, fitted carpeting. Wood floors were meant for show and small area rugs were recommended. William Morris produced several attractive carpet designs based on medieval forms. These, as well as imitations, were still manufactured by less-well-known companies. With a renewed interest in ethnic crafts of all kinds, rugs imported from India, Turkey, China, and other Eastern countries became popular. Gustav Stickley offered several rugs in his catalog, including simple designs with wide borders that echoed the inlaid borders of the floor.

In the United States there was a revival of the rag rug as a distinctive American craft. Two companies, Greenwich House in New York and the Greblo Rug Company in Minnesota, marketed rugs for bungalows and Arts &

Suggestions for Using Textiles in the Home from *The Modern Priscilla*

•

"Beautiful window frames, with perfect lines and artistic carving, would lose their value if hidden by curtains of heavy drapery. All that is needed for them is a glass curtain of thin, light material placed close to the sash."

•

"There are spots and places and byways and corners which, for reasons best known to the family, really should not be disclosed promiscuously to the public eye. How can it be done without friend screen? . . . a bit of decoration in itself to be prized as part of the furnishing of even the most pretentious house."

•

"Embroidery for the living room should be distinctive and the coloring gay and cheerful without being obtrusive enough to clash with any coloring a room may already have."

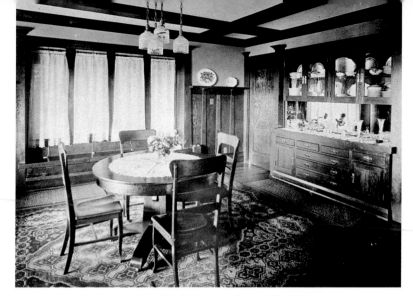

Dining room from *Keith's Magazine* showing Turkish carpet.

Crafts houses. Rugs were usually woven in simple patterns from scraps that had been dyed approximately the same color, or a few blended colors for a tweedy effect. If several fibers were dyed together (for example cotton, wool, and silk) the dye would affect each fiber slightly differently, creating a shadowy uneven surface. The more expensive rag rugs were colored with coal tar dyes instead of aniline, giving them richer and more stable colors.

These companies also produced hit-or-miss rag rugs in variegated colors of fabrics previously dyed or printed for other purposes. Manufacturers were proud to advertise that their rugs were truly made from rags. They used re-spun carpet scraps, trimmed and undyed selvedges, old portieres, and couch covers. These heavier fabrics worked best for carpets. A particularly heavy wool-scrap rug was recommended for bungalows because it was inexpensive and durable. Lighter-weight throw rugs and table runners were woven from old velvet dresses, chenille curtains, cotton underwear, and silk petticoats.

Patterns were made up of stripes, abstract geometric shapes, or simple outlines of pine trees, leaves, or other natural forms. Various patterned textures were used, and rugs were offered with a zigzag weave, diamond weave, or plain weave.

Although not as universal as needlework, weaving also became a popular hobby, and many women made their own rag rugs. Weaving schools were established for those who had no room for a loom at home, and small looms were sold that could be used to make runners or place mats.

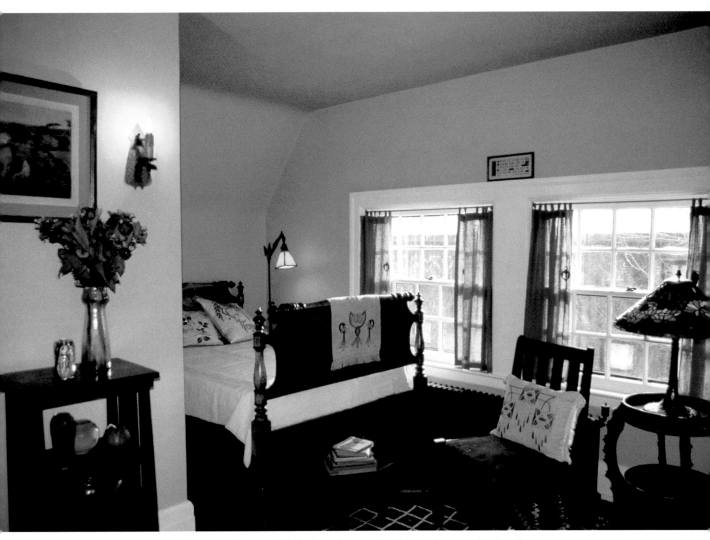

A bedroom designed by David Heide shows the use of textiles to enhance a soft color scheme;
textiles by Ann Wallace & Friends.

PHOTO COURTESY DAVID HEIDE DESIGN

Voile or sheer muslin curtains printed with colorful flowers were popular for informal Arts & Crafts rooms. Few have survived the effects of sun and dust, and their cheerful effect is often forgotten today. Curtain from the collection of Rosemary Kostansek; tablecloth from the collection of Tim Counts.

PHOTOGRAPH BY
PHIL BARD

The Bungalow

"All on one floor and very simple as to furnishing."
"Where housekeeping is possible when a maid is impossible."
—*Keith's Magazine*

Shelter magazines like *The Craftsman* and *Keith's Magazine* were promoters of these new affordable homes, although they did not always agree on the definition of a bungalow. In general, it was any small one-story or one-and-a-half-story house in colonial, Spanish, or any other style. But sometimes, they included two-story houses if they were informal, or they limited the definition to modest houses with a distinctly Arts & Crafts influence.

If the publishers had been asked a modern marketing question about the demographic profile of their readers, they would have described the bungalow owner as a do-it-yourselfer, prosperous but not wealthy, fairly well educated (which would have meant a high-school education), and living in one of the new housing developments just streetcar distance from downtown. They made a special point of featuring articles on the appropriate decor for these modest, informal houses. Women's magazines often featured embroidery projects with an Arts & Crafts look that were specifically designed for bungalows. All agreed that simplicity was particularly important in a bungalow. They favored burlap for walls, curtains, and cushions (hopefully not all in the same room), as well as rougher linens and linen blends. Cushions and table runners would have simple stitching with appliqué and stenciling. Print fabrics for curtains and upholstery would be informal cottage florals.

Gustav Stickley particularly recommended his Craftsman Canvas, a blend of jute and linen that resembled burlap, for a rugged effect. It was available in mainly earthen colors: weather-beaten oak, dark russet, deep leaf green, eucalyptus, brick, and ripe wheat.

Embroidery designs specifically meant for bungalows featured the ubiquitous pinecone as well as simplified representations of other flowers and plants. An article on embroidery for the bungalow in *The Modern Priscilla* showed fairly standard patterns worked on dark green burlap in shades of golden brown and green with pink accents. The pink accents are unusual but the green-and-gold color scheme is classic, as is the use of sturdy burlap.

Decorating Suggestions
from *Keith's Magazine*, 1905 to 1915

Tip: Preventing Mildew on Shower Curtains

All shower curtains, but particularly those made from canvas, are susceptible to mildew if they cannot dry out between showers. Leave the shower curtain pulled closed and flat so that moisture is not caught in its folds. With bath and shower combinations, moisture is trapped between the curtain and the edge of the tub and the bottom of the curtain often mildews. Shower with the curtain inside the tub to contain splashes, but afterward, pull the curtain outside the tub so it can dry.

• "Do not edge pillows with fancy ruffles, ribbons or cord."

• "It will be found that a closely set pattern of harmonious coloring is more serviceable in the dining room carpet than one of plain color and no pronounced design. This is because it keeps in better condition without showing wear and tear."

• "A curtainless room has a dreary, unfinished appearance, but one that has the right amount of drapery has a charm felt by all who enter."

• "A cushioned window seat gives a cozy and inviting appearance to the interior and a suggestion of informality that makes itself felt."

• "It is pleasant to chronical [sic] the passing of the lace curtain . . . it is no longer bought by people of taste."

• "Too much emphasis cannot be laid on the fact that with a rather dark, although bright, color scheme the conventional white thin curtain is out of place."

• "The up-to-date bed has its day dress to correspondence with the furnishings of the room. Its pillows are removed to a convenient closet during the day and their place supplied by a round bolster."

• "If your home is in a dirty section of town, do not use light colored fabrics."

• "The breakfast room should have many windows that look into the garden or out upon some other pretty scene. The curtains should be in light, delicate colors."

• "The bedroom must be well lighted and carefully ventilated and a good deal of restraint in furnishing is necessary to make it altogether sanitary. The room in which one sleeps must be simple in order to be hygienic. Use the same curtain fabric for the bedspread and pillow sham."

• "The draperies in a Bungalow are generally of a little coarser texture than in houses of strictly Colonial, Elizabethan or Italian—although silk is always satisfactory."

• "Correct color harmony, because it is more restful to the temperament, is more enduringly satisfying than any mere pattern, which is usually arranged in the studio of the designer, and without reference to the particular case to which it might be applied."

• "Nothing is more depressing and more subtle in its effect upon our spirits, than to live constantly in dull, colorless rooms, and nothing is

Additional Reading:
Smith, Bruce, and Yoshiko Yamamoto. *The Beautiful Necessity, Decorating with Arts & Crafts* (Salt Lake City: Gibbs Smith, Publisher, 1996).

more cheering and conducive to good feeling than to enter a room in which the color scheme is a pleasant surprise and reminds us of some beautiful aspect of nature."

• "The practice of getting rid of old, faded draperies by furnishing the children's room with them is really to distort the growing artistic taste in the coming generations, and to show that we ourselves have no true conception of the word artistic."

"One has to visit an Arts & Crafts exhibition to realize what effective things can be done with cheap materials, given a little patience and ingenuity."
—*Keith's Magazine*, 1912

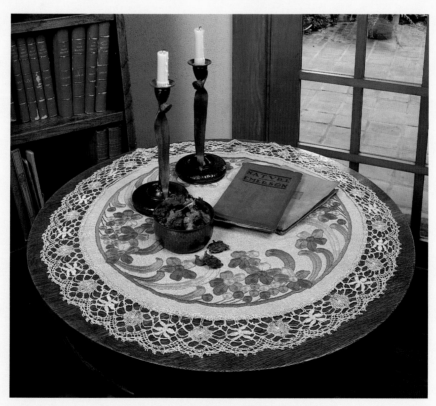

Centerpiece from the collection of Rosemary Kostansek.

PHOTOGRAPH BY PHIL BARD

Using Arts & Crafts Textiles Today

DAVID HEIDE
Designing Where Architecture and Decor Meet

David Heide specializes in historic design and preservation. Growing up in Des Moines, Iowa, he remembers exploring the historic Salisbury House as a very young child and being totally taken by the romance of old architecture.

Although he works with all styles of architecture, he has a special appreciation for the Arts & Crafts period. He feels that it managed to move architecture and decoration forward from the Victorian styles that were less practical for twentieth-century life while managing to preserve textures and colors that improve with age. The fumed oak, natural linens, and earth-tone colors almost seem old to begin with. The patina of Arts & Crafts interiors improves with age, Heide feels, while other twentieth-century styles need to be new and crisp to work. He also notes that on a practical level, the floor plan of the Arts & Crafts house is well suited to contemporary life.

Urging his clients to budget and prioritize before they start, Heide says that this is one of the most difficult things to do. He works from the beginning to develop a concept for the entire project. A clear concept and direction make decisions easier and ensure efficiency. With all the uncontrollable delays that can occur, why add waiting for the rug to arrive before selecting stencil colors? This is particularly important with textiles since floor coverings, upholstery, and drapery will all be made and delivered on different schedules.

Heide likes to vary window treatments using curtains, Roman shades, wooden blinds, or roller blinds as appropriate. He points out that Arts & Crafts window coverings fit *within* the elevation of the wall. If they are imposed *on* it, draperies look clumsy. Fabrics were usually sheer, loosely woven, or at least unlined. The designers of the period often spoke of the warm quality of light filtered through fabric. The appliqués and stenciling on these curtains were based on the same natural forms seen outside the window and thus served as a sort of transitional element between interior and exterior space. Each window, even in a grouping, is usually covered individually, creating what Heide considers to be a charming tactile ritual of operation as each curtain or shade is opened and closed. Heide points out that the drapery hardware typically shows an appreciation of the "works" in the Arts & Crafts style as seen in the exposed joints and prominent hardware of the furniture.

A living room designed by David Heide. Note the use of area rugs with vintage and reproduction textiles. Textiles by Ann Wallace & Friends.

PHOTO COURTESY
DAVID HEIDE DESIGN

Mixing modern and reproduction textiles with vintage pieces is a technique Heide uses. He suggests using incidental embroidered pieces, such as laundry bags, as pillows, since they are often less expensive. He also buys slightly damaged pieces, noting that even with the price of repair, they are usually less expensive than vintage pieces in good condition. His own favorite textile is a set of portieres he found in Middle River, Minnesota. They include a beautiful pattern in rich coppery colors. He found them in their original box, apparently never used, and of course, at a great price.

Heide often looks for antiques for clients, sometimes buying "on approval" or putting things on hold. He also prepares his clients who like to shop themselves, arming them with pictures of things to look for. He encourages his clients to use color, to move away from white walls and blond floors, and savor instead the warmth of the Arts & Crafts palette. "After all," Heide says, "we have electric light now."

Appliquéd curtains echo the stenciled walls in this dining room designed by David Heide. Textiles by Ann Wallace & Friends.

PHOTO COURTESY DAVID HEIDE DESIGN

Colorful rugs and an unusual vintage portiere accent a narrow hall designed by David Heide.

PHOTO COURTESY DAVID HEIDE DESIGN

MARTI WACHTEL
Using the Arts & Crafts Style in the Real World

Interior designer Marti Wachtel was inspired to focus her business, Circa Design, on historic preservation, particularly the Arts & Crafts movement. After meticulously restoring her own charming bungalow in the Hanchett Park neighborhood of San Jose, she became committed to saving these charming houses and to sharing what she learned. In the Arts & Crafts tradition, she eventually became a member of the board of directors of her neighborhood association and of the Historic Landmarks Commission for the City of San Jose.

One thing Wachtel tells her clients is that if they like the period, other things they enjoy will probably work in their interior designs. She believes that it is more important to be true to the spirit of the Arts & Crafts style than to slavishly seek period accuracy. Wachtel freely uses a variety of ethnic crafts in her interior designs, seeking a well-traveled look with an appreciation for all kinds of handiwork. She mixes various vintage and contemporary textiles (pointing out that these pieces are often less expensive and easier to find), blending with Arts & Crafts pieces and using contemporary prints and tapestry weaves with William Morris prints. Wachtel points out that after studying the period, it is easy to see the enormous influence designers such as Morris, Frank Lloyd

Wright, and Hoffman have had on textile design. Many contemporary textiles are so similar that they make an excellent affordable alternative to the more expensive reproductions.

Mixing Arts & Crafts reproduction rugs with ethnic pieces and contemporary area rugs is a Wachtel specialty. For example, she used an important and colorful Bokhara to bring interest to a long, rather dull hallway but used neutral wool sisal carpeting to give a small living room and dining room a spacious feeling and to serve as a canvas for her richly colored Arts & Crafts furniture and textiles. In a study furnished mainly with office furniture, she used a reproduction of an informal Stickley dhurrie to bring additional period detail to the room.

Wachtel likes to see some kind of window covering to soften a room. She uses Roman shades for a more crisp look or when she wants to maximize light. She chooses curtains for a softer look with sunlight filtered through light fabrics.

Committed to supporting late-twentieth-century Arts & Crafts artisans, for her own house Wachtel commissioned tiles, window treatments, textiles, carpets, and cabinetry from modern craftsmen who could interpret her ideas in a period-appropriate but contemporary style. She points out that most people have inherited furniture or beloved pieces that are not Arts & Crafts. She sees no reason to discard these pieces, because the Arts & Crafts style has a unique ability to accommodate other periods and styles. Many things from African to early Victorian blend superbly with Arts & Crafts.

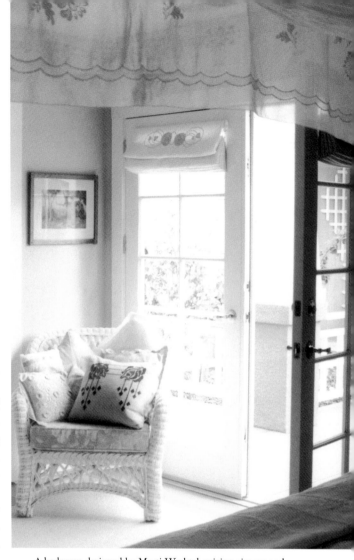

A bedroom designed by Marti Wachtel, mixing vintage and contemporary textiles. Vintage table linens were adapted for the bed linens. Bedrooms in Arts & Crafts houses are often brighter than the public rooms, with light painted woodwork and walls.

PHOTO COURTESY CIRCA DESIGN

TIM COUNTS
Arts & Crafts Charm on a Shoestring

Tim Counts is not a professional interior designer, but his Minneapolis house has been featured in a national magazine. This is not surprising, considering how attractively he has decorated it. What is surprising is how little money he has spent.

He purchased his home in Minneapolis because it was inexpensive, but he soon became particularly interested in what one might call the "culture of affordability" surrounding the bungalow. He noticed that period magazines emphasized the easy and inexpensive lifestyle possible with these small charming houses. In this spirit, he decided to make restoring his house and purchasing furnishings a kind of game, trying to do as much as he could for as little as possible. He finished his house with a series of grants and low-interest loans that were made available to encourage people to maintain houses in downtown neighborhoods.

A notorious penny-pincher and bargain hunter, Counts has spent a surprisingly small amount of money to decorate a house that is more than just a match for many extravagant restorations. He bought contemporary furniture and altered it to make it look more Arts & Crafts, doing much of the work himself. Counts gradually added textiles that he feels were an inexpensive way to give an Arts & Crafts look to a room that may otherwise be furnished with neutral-looking furnishings. He mixed vintage and contemporary pieces freely.

When he first started purchasing textiles, Counts was not certain what to look for, but, by attending Arts & Crafts conferences and house tours, he became an educated shopper and slowly upgraded his collection. Counts' most important tip for finding textile bargains is to be patient and shop often. He admits that, for him, browsing antiques shops is a favorite form of relaxation. He is happy to just window shop and feels that time spent looking at things he cannot afford to buy is at least a valuable education. Counts also purchases vintage magazines and books to display and to contribute to his knowledge.

For the best bargains, Counts recommends getting as far away from major urban markets and resort areas as possible. Anyplace that is farther away than a day's visit will offer better bargains. He also finds good prices in urban antiques malls, where a wide range of quality seems to keep prices down. Counts usually asks for and receives a 10-percent discount. He occasionally offers a lower price, which is often refused. Since he is rarely interested in a piece unless it is already fairly reasonable, he does not make a point of bargaining ruthlessly and will

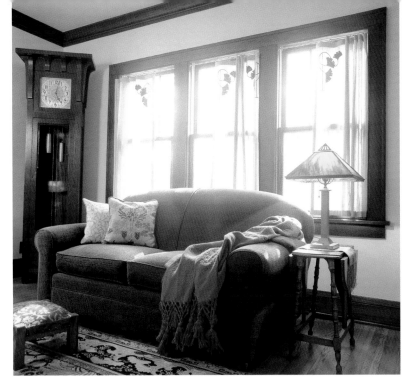

Tim Counts furnished his bungalow on a shoestring, mixing new pieces with the affordable antiques that he looks for so carefully. Appliquéd curtains from Ann Wallace & Friends are used with vintage textiles.

PHOTOGRAPH BY WILLIAM S. CLARK; STYLING BY RENE E. NARI

often pay the asking price. Counts is also willing to buy textiles that are somewhat damaged. In fact, he actually prefers pieces that show some wear, believing that the patina of use adds a sort of romantic value to his favorite things.

Some of Counts' bargains include an unfinished pillow top, richly embroidered with red poppies, that he found at a reduced price in an antiques mall. It was a lavishly embroidered blue poppy pillow that he found in a pile of other less-valuable textiles. Also, he found a horsehair sleigh blanket embellished with Arts & Crafts roses—an unusual item that few people would know what to do with, but it makes a terrific lap robe for cold winter evenings.

Counts' attractive house is a reminder that even as Arts & Crafts antiques become more and more expensive, the spirit and atmosphere of the style can be created very inexpensively. Textiles made from a kit and purchased slightly damaged, or found by chance after many days of shopping, are an important and affordable contribution to an inviting Arts & Crafts interior.

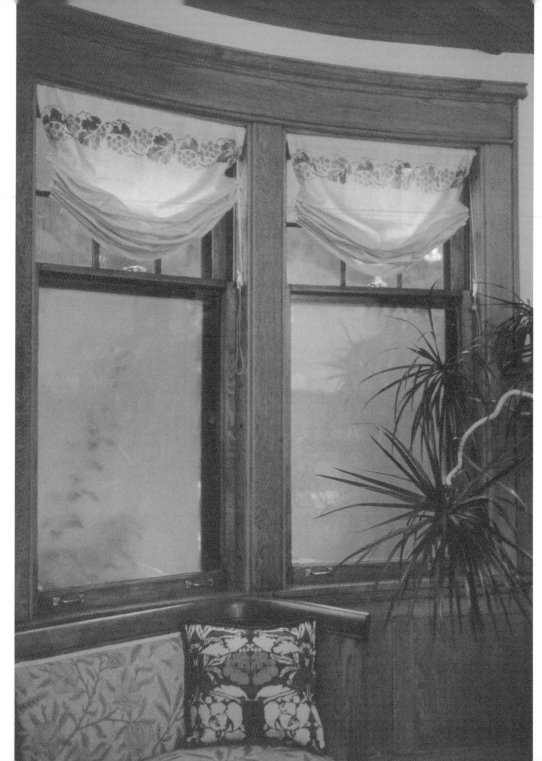

Relaxed Roman shades in raw silk with a grapevine stencil make an elegant swag effect in a more formal dining room, but they are also completely functional. The parlor sofa upholstery and needlepoint pillow are William Morris designs. Shades by Ann Wallace & Friends.

PHOTOGRAPH BY
VINCENT DIGABRIELE

A FEW EXTRA WORDS ABOUT WINDOWS

"It is always a problem to choose curtains, and too much thought cannot be given to this all important subject."
—*Keith's Magazine*, 1911

Of all home textiles, curtains and shades seem to require the most thought. This is understandable because while they should be attractive, they also need to work. The return to simple vertical curtains and drapes, as seen in Arts & Crafts interiors from William Morris to the present time, started as a reaction to the over-elaborate French drapery of High Victorian interior design. The tendency to bury the window beneath swags and layers of extra-long drapery, trimmed with layers of braid and bullion is still with us. In addition, many of us remember the unfortunate rigidly pleated fiberglass drapes of the 1950s and '60s and the cheap ready-made draperies that attempted a rich look with too little fabric. In reaction, many people have chosen to forego window coverings completely, but curtains need not be obtrusive. Skeptical homeowners are often quite surprised at how practical they are, and how they finish a room.

Not every window needs curtains. It would be ridiculous to curtain a beautifully framed stained-glass window. The high casement windows frequently seen in Arts & Crafts houses often look best without fabric, if the view is of something attractive, like greenery. On the other hand, these "piano windows" may overlook the wall of another house or have a western exposure that lets in too much direct sunlight. In this case, a light curtain is useful and attractive.

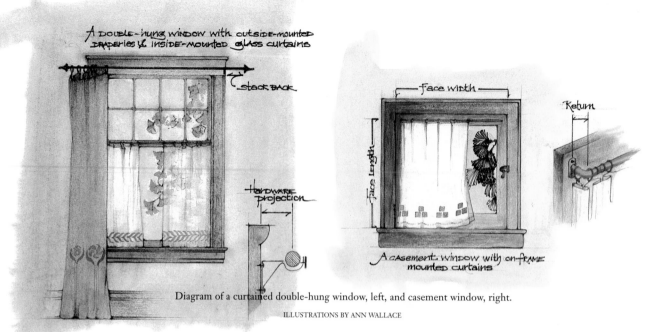

A DOUBLE-hung window with outside-mounted DRAPERIES & inside-mounted GLASS curtains

stack BACK

Hardware projection

Face width

Face Length

Return

A casement window with on-frame mounted curtains

Diagram of a curtained double-hung window, left, and casement window, right.

ILLUSTRATIONS BY ANN WALLACE

In older homes, casements usually operate like a small door that opens into a room. Curtains are usually mounted "on frame." This means that the curtain rod is attached to the frame of the working part of the window so that when the window is opened, the curtain comes with it. In contemporary construction, the window is more likely to open out, usually with a crank. In this case, the curtain may be mounted on the outer frame of the window.

Double-hung windows are the most common window construction. They have two inside frames or sashes that are counterweighted and slide up and down on tracks. In Arts & Crafts houses, the lower frame is often two-thirds the height of the window. If a window has attractive woodwork, curtains can be mounted *inside* the outer window frame, but they should not be mounted *on* the inside frame where they will get in the way when the window is opened. Older windows with old-fashioned counterweights usually have a wide flat panel set at 90 degrees between the outer and inner frames. This panel contains brass screws so that it can be removed when replacing the sash cord that holds the counterweight. Sockets for inside-mounted curtains should be attached near the front edge of this panel. Modern windows do not use counterweights, and the recess that separates the outer and inner frames usually steps back in a series of small pieces of molding. You must decide where you want the curtain to hang and make sure that there is enough surface area to accommodate the socket.

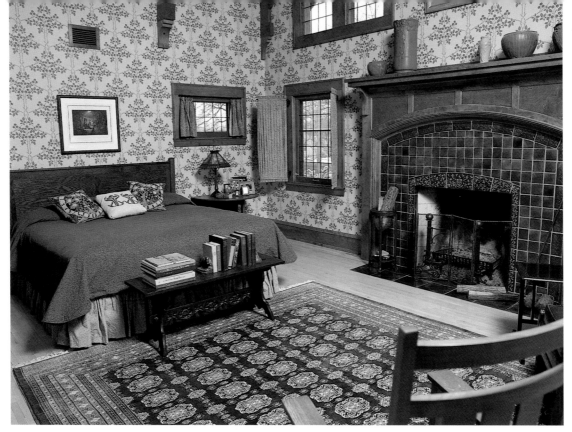

Suzanne Maurer & Associates designed a grand master bedroom using William Morris patterns mixed with American Arts & Crafts textiles. Note the use of curtains on the small casement windows and pleated fabric shutters on the larger double-hung windows. Textiles by Ann Wallace & Friends.

PHOTOGRAPH BY PETER BECK

A narrow three-eighths-inch inside-mounted curtain rod will fit about half an inch from the top inside edge of the window frame. This distance accommodates the socket mounts and allows space for the curtain to move freely. If this open space between the rod and the top of the window frame bothers you, your curtain should have a header. A header is a narrow ruffle formed when an extra fold of fabric is allowed above the rod pocket (only rod-pocket curtains can be made with headers). This little ruffle fills in the space nicely between the rod and the window top. A header looks ridiculous if it is less than an inch deep, so the rod placement will have to be dropped slightly to accommodate it.

Magazines of the period often suggest using inside-mounted curtains only on the bottom half of double-hung windows. This allows light to come in while giving some privacy and is a particularly attractive treatment for a front sun porch or for windows that are very close to a neighboring house.

Curtains may also be effectively mounted on the outer window frame for double-hung windows. The outside-mount bracket is usually attached close to the outer edge of the frame. This allows the curtain to be opened a bit farther, uncovering more of the glass.

Since Arts & Crafts interiors can be dark, homeowners are often eager to open curtains as much as possible. To completely clear the glass, a curtain usually requires a stack back. A stack back is several inches (traditionally one-third the width of the window) of extra curtain rod extending beyond the window on either side so that the fully opened curtain is in front of the wall instead of the window. A large stack back is not usually appropriate for an Arts & Crafts house. Even in modest bungalows, the design of each wall with its relationship of window, molding, light fixtures, and built-in furniture is carefully designed. The added curtain width changes the proportions of the window, conceals the woodwork, and often gets in the way of other decorative molding and sconces. Since appropriate curtains are not usually very full, three or four inches of curtain rod between the bracket and the finial may allow enough stack back to clear most of the glass.

Traditionally, curtains are made double or even triple fullness. This means that if the window is 40 inches wide, the finished curtain will be 80 inches or even 120 inches wide if spread out flat. Arts & Crafts curtains are usually one-and-one-half fullness, or 60 inches wide for a 40-inch window. This means that the curtain is full enough to have some softness when it is closed but takes up a minimal amount of space when opened. In Arts & Crafts houses of a more modern style, reminiscent of Wright or Mackintosh, flat panel curtains that appear to be no fuller then the width of the window may be desired. The panel will actually be cut with a few inches of extra fullness to allow for the drape of the fabric.

An additional way to open curtains off the window glass is to consider how they are mounted to the rod. The more fabric bulk there is on the rod, the less the curtains will open. A curtain with a rod pocket top has the full width of the panel on the rod. Some bulk is removed if the curtain has a tab top, but tabs still have some thickness. Rings take up the least amount of space on the rod and allow you to open the curtain the most. The smaller and fewer the rings the better. Fewer rings can be used if the top of the curtain panel is pleated

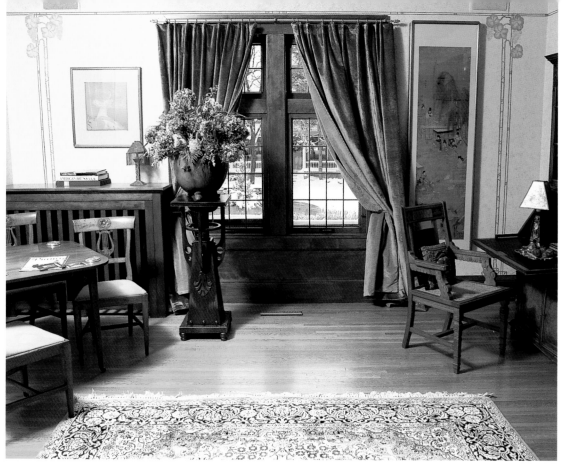

A fairly formal living room with simple draperies by Suzanne Maurer & Associates.
These single-pleated, one-and-one-half fullness velvet drapes provide insulation
in wintry weather. Drapes by Ann Wallace & Friends.

PHOTOGRAPH BY PETER BECK

to only a few inches wider than the actual window width. Avoid elaborate decorative pleating.

Curtains can also be held off the window glass with holdbacks or tiebacks. These are often associated with elaborate passementerie constructions of cords and tassels, or with ruffled, excessively cute cottage curtains. Simple fabric or cord ties used in a tailored style without swagging the fabric are entirely appropriate and hardly noticeable. When used originally, they were considered functional and were hooked and unhooked as needed. This can still be done, but the ties will inevitably leave some creases in the curtains.

Windows in Arts & Crafts houses often come in groups; banks of two, three, four or more windows of the same size or a large window flanked by two smaller ones. The contemporary way to dress a bank of windows is to treat them as one large window with the sheer inside curtain and the outer drape hanging from the same point. This seldom works for the Arts & Crafts house. The bank of windows and the way they are framed is usually important architecturally, and a wall of curtains conceals the planned grouping. Traditionally, each separate window should have its own sheer curtain covering the entire window or only the bottom half. Curtains in velvet or heavy linen may be mounted on the outer frame and drawn across the entire bank of windows if insulation or greater shade is desired. This use of individual sheers with a unifying outer curtain preserves the composition of the separate windows and unifies them at the same time. In fact, stenciled scrim or net sheers on the bottom half of each window in a bank, with appliquéd velvet or linen outer curtains, is a classic Arts & Crafts window treatment.

Curtains for windows in doors present a special case. Traditionally, rod-pocket curtains were mounted with a rod at the top and at the bottom to keep the curtain from catching in a frequently used door. This looks best if tension on the curtain holds the folds taut, so it does not work with rings or tabs. French doors may be curtained the same way. However, since they often function as a window as well as a door, curtains that are more easily opened may be preferred. Light curtains with rings, mounted on the door frame and just covering the glass, can be easily opened.

Garden and veranda doors often have heavier drapes hung on curtain cranes. A curtain crane is a rod mounted on a single pivoting bracket. The bracket is attached to the outside frame of the door. When mounted, the curtain can hang in front of the door to provide privacy or insulation, but it can be swung out of the way and completely off the door for a maximum amount of light. In addition, the curtain crane clears the door to allow opening it easily.

Portieres are usually hung within the doorway frame so that the mounting looks the same from both sides. Rings are recommended for ease of opening. Portieres are constructed so that they appear finished on each side. Often, they are embroidered in a color scheme appropriate to the interior they face. Even if only one side is decorated, the other side is finished with the same or another decorator fabric, not a lining.

Portieres are used here in a contemporary interior to separate the study from the living room.
"Tree of Life" portieres from Ann Wallace & Friends; rug from Kelly Marshall.

PHOTOGRAPH BY PHIL BARD

Hardware

Hardware for Arts & Crafts curtains should be simple and functional and it should not be concealed. Plastic parts and thin white oval rodding should not be used. Elaborate pulley systems for closing the drapes should be avoided. To keep from overhandling the fabric, or for drapes that are too high to reach easily, use a baton. Commercial batons are sturdy fiberglass sticks with a clip at one end. This clip hooks to the bottom of the ring at the leading edge of the curtain. Holding the other end, you can easily draw the curtain. Wooden batons can be made from doweling with a small screw eye at one end. Use one made from hardwood for greater strength.

For light curtains, especially inside-mounted and on-frame, three-eighths-inch brass rodding is the best choice. This was the most common hardware used at the beginning of the century and it is still available today. If you have an older house, you can probably find the old screw holes in your woodwork where hardware for three-eighths-inch rodding was mounted.

The following items are a sample of the variety of hardware that is available for mounting three-eighths-inch rodding:

• Sockets: Used for inside-mounted curtains, these require at least a five-eighths-inch surface perpendicular to the rod for attachment.

• Outside-mount barrel brackets: Projecting about an inch, these can be used for all types of mounts but are particularly suited to on-frame mounting for doors and casements where their short projection will not interfere with the function of the door or window.

• Gooseneck barrel brackets: Available in one-inch and up to five-inch projections, these brackets allow a smooth return for a valance or a curtain that needs to project over something, like an inner curtain, a shade, or a window-mounted air-conditioner. Their curved sides allow rings or fabric to move easily around the corner of the return.

• Drop-in brackets, inside and outside mount: Available in various projections and with a double bracket that supports two rods for a sheer and an overlay, these brackets are used when the screw-on barrel is too difficult to attach. They are less stable because they hold the rod less firmly.

• Spring-mount brackets: These are for inside-mounted curtains where the surface cannot accommodate a screw (such as in stone or concrete) or woodwork or surfaces you have carefully restored and cannot bear to drill a hole into.

Mounting hardware for curtain rods: (a) gooseneck bracket, (b) sockets for inside-mounted rods, (c) outside-mount brackets, (d) inside-mount drop-in brackets, (e) outside-mount drop-in brackets, (f) spring-mount brackets.

ILLUSTRATION BY ANN WALLACE

These hardware options work with all top treatments. Appropriate rings are small brass eyelets about the size of a woman's wedding ring.

Because three-eighths-inch rodding is so narrow, it can only span about forty-five inches without sagging. A small brass center support can be used if the window has two panels. If a center support cannot be used because of the molding design or curtain placement, heavier hardware will be necessary.

For wider spans, one-inch or one-and-a-half-inch brass or wrought iron with matching brackets and a simple finial are good choices. The heavier brass can also be inside-mounted with a socket. Wooden rods and finials are not usually a good choice. Unless the window elevation is fairly large, the brackets look particularly massive. In addition, the stain of the rods often clashes with the stain of the woodwork.

If the bright brass finish of the hardware is objectionable, the lacquer coating can be removed with thinner and the brass can be antiqued in a diluted acid bath. Since brass plating is very thin, it is even better to remove the lacquer and let the brass oxidize naturally by itself.

Once curtains are hung, they should be dressed. Fabric, particularly of natural fiber, has memory and can be trained to fall in soft vertical folds. Open the curtains all the way and gently arrange them in soft folds. If the curtains have tabs or rings, pull the folds formed between the rings outward. It is actually preferable if the folds do not all look exactly alike. Wrap the folds with scraps of fabric or wide pieces of paper about two feet apart. Leave them for two weeks.

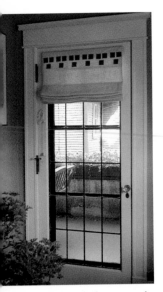

In period houses, practical inside-mounted roller shades in white and dark green were commonly used in combination with curtains. Wooden blinds were seldom used, except occasionally on porches. They were considered vaguely industrial and better suited to offices.

Pleated shades in heavier fabrics, called Roman shades, were seldom used in smaller homes although they had been in existence for hundreds of years. This may seem surprising since a soft fabric shade, mounted inside a window frame, seems like an ideal solution for providing light and shadow with a minimal amount of fabric. However, most curtains for the more modest Arts & Crafts houses were purchased ready-made or easily sewn by the home owner. Shades must be custom made, especially if they are to be inside mounted, and they require fairly complicated hardware and rigging, not available in hardware stores.

Roman shades fold up like an accordion with pleats that are usually three to five inches deep. When the shade is up, the pleats line up behind the topmost pleat so that any decoration on the bottom edge of the shade will not show. If the shade is to be stenciled or appliquéd, it may work best along the top edge. A traditional Roman shade contains cording threaded along the back, every twelve inches or so, to support it even in horizontal folds. A relaxed Roman shade contains cording only at the outside edges so that it naturally collapses a bit in the center like a small swag. The amount of collapse depends on the width of the shade. This natural drape can be very attractive.

Roman shades also work well on French doors since they can open out of the way to let in light. If the same fabric is used, Roman shades and simple curtains can be used together in the same room to accommodate the variety of windows and doors that are often mixed in Arts & Crafts.

Roman shades mounted on-frame make an excellent covering for a glass door, providing privacy with maximum light when opened. Note that the appliqué motif is placed on the top face pleat so that it will show even when the shade is up. Shade by Ann Wallace & Friends.

PHOTOGRAPH BY
VINCENT DIGABRIELE

Stencil designs recommended for curtains and table linens
from *The Embroidery Book*, 1914.

Working with Fabric Drape

One of the most valued qualities of fabric is its drape. Each weight and weave of fabric has its own response to gravity as shown in the fullness of its folds and the directness of their fall.

The nicest curtains take advantage of this property and do not work against it (hence the name drapery). Fabric can be stuffed, pinned, tacked, and tied to hold an artificial shape, so that it might as well be papier-mâché. Arts & Crafts curtains, particularly, should appear completely natural and un-styled when hung.

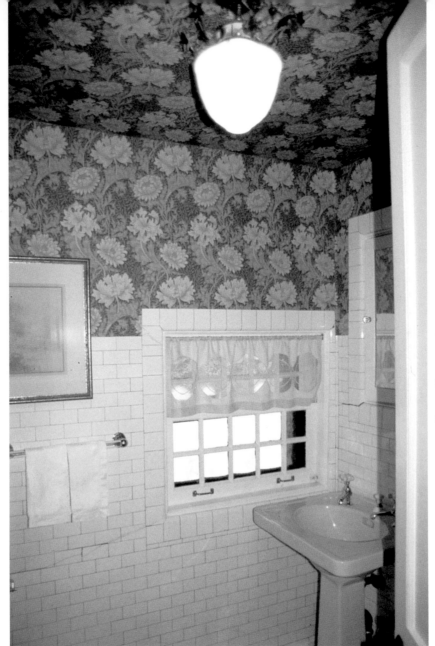

Working with Printed Fabrics

Most Arts & Crafts curtains were solid in color, but prints were also used for sheers and outer drapes. William Morris and Candace Wheeler designed fabrics that are still available today and that make lovely curtains. However, printed fabrics for home decorating often have very large repeats. A single repeat is a complete pattern of the printed design and it may be as wide as forty inches.

The repeat must be matched horizontally and vertically at fabric seams and across all curtain panels for all windows. This may require considerable extra yardage.

Unless you are an experienced seamstress, you should work with a drapery workroom if you want printed curtains.

A bathroom designed by David Heide uses a cutwork curtain
to provide light and privacy in a period setting.

PHOTO COURTESY DAVID HEIDE DESIGNS

THE ARTS & CRAFTS MOVEMENT AND WOMEN'S FASHION

"Between 1906 and 1914, corsets began to lose their hold
and women could breathe again."

—*Quentin Bell*, On Human Finery

The textile art of the Arts & Crafts movement is composed mostly of surface design. Although forms were simplified and excessive decoration eliminated, basic shape remained the same. In this, Arts & Crafts textiles have more in common with graphic design than furniture or architecture.

However, in women's clothing, the Arts & Crafts movement was associated with a gradual but revolutionary change in silhouette. As usual, in Western culture, women's fashions were much more radically influenced by cultural trends, but men's clothing was also affected. Clothing was influenced by the general desire of artists and craftsmen to throw off the formalism and stiffness of the first part of the nineteenth century. In Great Britain and the United States, where fashion often goes hand in hand with politics, style was influenced by the new political ideas of Fabian socialism, first-wave feminism, and something called "dress reform."

Much of the dress reform movement was directed against the corset. Advocates of simple loose-fitting clothing pointed out correctly that tight lacing displaced the internal organs, inhibited breathing, and weakened muscles. Unfortunately, the clothing they promoted was quite unattractive and often was made fun of.

Simply cut dresses with embroidery inserts or borders from *The Embroidery Book*, 1914.

The followers of the Pre-Raphaelites adopted a medieval simplicity in their dress. In photographs, William Morris's wife, Jane, and his two daughters wore simple dresses untrimmed except for a bit of embroidery at the neck. The women wore bodices that were gathered, not fitted, and they often appeared to be uncorseted. To the modern eye, these dresses do not look terribly different from other dresses of the period, but at that time, their simplicity and softness was shocking. In fact, these clothes were slightly modernized versions of the clothing worn by the maidens in Pre-Raphaelite paintings. The romantic paintings made simpler clothing and more natural silhouettes seem romantic to many women.

Liberty of London popularized a version of this style of dress. Liberty dresses were often made of printed fabrics in designs influenced by favorite decorative motifs of the Aesthetics movement such as Japonaiserie, lilies, sunflowers, and peacock feathers. Many Liberty prints of this period are still manufactured today. Printed on fine cotton with smaller-scale designs and repeats, they are some of the few Arts & Crafts fabrics available today that are suitable for clothing.

The illustrator Kate Greenaway was also a great popularizer of more informal dress. Her drawings, mostly of children dressed in invented half-Georgian, half-Regency "quaint" clothing, were admired by John Ruskin. They continue to be immensely popular, and, at the time, were a great influence on fashion.

Male followers of the Arts & Crafts movement were content at first to replace the heavy starch collar and cravat with a soft collar and bow. This style of neckwear was later adopted by Elbert Hubbard as a sort of homage to William Morris. More fashion-conscious male Aesthetes, such as Oscar Wilde, dressed in velvet suits with knee breeches, like the boys in Kate Greenaway's watercolors.

"Artistic" dress was associated with liberal politics such as Fabian socialism, women's suffrage, and a Bohemian lifestyle. It took the French to make this relaxed silhouette truly fashionable. At the beginning of the twentieth century, the radical fashion designer Paul Poiret, inspired by Art Nouveau and the exotic physicality of the Ballet Russe, introduced a style that seemed outrageous and totally new. It was actually reform dress—beautifully cut, richly colored and embroidered, and therefore, unrecognizable. Skirts were shortened to ankle length, waists were natural, and, while corsets were still worn, they were not strictly necessary.

Color plate from *Kate Greenaway's Birthday Book*. Greenaway's illustrations were much admired by John Ruskin and were a strong influence on both aesthetic dress and children's illustration.

The new style was practical and timely. Women were entering the workforce as office workers, nurses, teachers, and, more than in any other field, as workers in textiles and related industries. In 1859, a total of 5,739 people worked in the textile industries. Eighty-five percent of them were women. By 1900, the number was up to 96,000. The main item of mass-produced clothing was the woman's blouse, called a waist or shirtwaist. A practical shirtwaist and a skirt was the standard uniform for working women.

The new relaxed silhouette made this style even easier to wear. The 1906 Sears and Roebuck catalog showed women's clothing in the swayback, hourglass silhouette of the Edwardian period. By 1914 the silhouette had completely changed, but the controversy over corsets continued. Reformers urged a change to more "hygienic" suits of cotton or wool underwear. However, many women were too used to their corsets to give them up, although the silhouette was much more natural.

Jessie Newbery, embroidery teacher at the Glasgow School of Art, was an advocate of dress reform at the beginning of the century. Inspired by the Pre-Raphaelites, she designed her own wedding dress based on a Venetian painting of Saint Ursula. She also designed loose-fitting tunics and dresses that provided a simple background for her embroidery.

An afternoon dress with embroidery from
The Modern Priscilla, 1914. Even with the newly popular
hobble skirt, this relaxed style of dress was much easier to wear
than clothing popular at the beginning of the century.

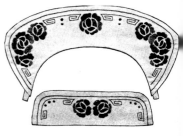

Detachable collars and
cuffs could be embroidered
to add color to simple
shirtwaists and were often
featured as embroidery
projects in ladies'
magazines.

Detail of embroidery on dress at left, designed by Ethel Rose
for *Priscilla* readers. Ms. Rose recommended white, brown, and red
embroidery on natural linen or black, red, and white on blue serge.
The design was available stamped on several shades of linen or
could be transferred onto the customer's own fabric.

In the United States, the new uniform was enthusiastically adopted across all class lines. Simpler shirtwaists were styled like men's shirts in cotton or linen. Elegant silk shirtwaists were worn in the evening. These shirtwaists often had detachable collars and cuffs—a practical idea, since they were most likely to get dirty and could be laundered separately. A set of collar and cuffs was an obvious site for embroidery. Ladies' magazines of the era contained ads for stamped collars and cuffs ready for stitching as well as numerous patterns for transfer.

Aprons were also a popular project for art needlework. They were worn much more frequently to protect clothing, since laundry still was done by hand and ironing was heavy, hot work.

World War I played an enormous role in hastening the adoption of this easier style. Women served as nurses and in other volunteer positions in the army, and replaced men in factories. Working-class women were not available as servants, so all women had to do more of their own housework. It became acceptable to wear pants in loose feminine styles for gardening and other physical work.

Practical, but presumably elegant, work clothing was shown in ladies' magazines, which featured overalls, divided skirts, and breeches for really active wear, as well as smocks. The *Ladies' Home Journal* featured a pattern for a "bungalow coverall." It was a shapeless over-tunic with a back closure, rather like a hospital gown. This offered full protection for the woman living in one of the new bungalows and doing all of her own housekeeping.

The beginning of the century was a transitional time for home dressmaking. Store-bought clothing was not at first considered the best quality. Upper-middle-class women still used dressmakers for their own and their children's clothing. Dresses, skirts and blouses often had front panels or borders that could be embroidered, and the magazines published art needlework designs for use on clothing finished by dressmakers. Middle-class women made their own clothing, but as the quality of readymade clothing improved, they began to purchase coats, suits, and finally dresses and skirts from shops and mail-order catalogs. Gradually, more women's clothing was purchased readymade and most home sewing was done for children. Many charming embroidery and appliqué designs were created for children's clothing, and magazines featured extra supplements devoted exclusively to designs for children.

With the depression, clothing became simpler and less embellished. Women made clothing for themselves and their children, but it was much simpler than before.

14141 — Two bag designs with cutting patterns. They may be developed in colors in solid work and outline-stitch. 10 cents.

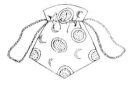

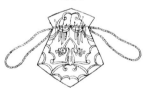

Embroidery designs for purses from *The Embroidery Book,* 1914.

HOW TO CREATE ARTS & CRAFTS TEXTILES

"Never forget the material you are working with, and try always to use it for doing what it can do best: if you feel yourself hampered by the material in which you are working, instead of being helped by it, you have so far not learned your business."

—William Morris

With its emphasis on the pleasures and benefits of handwork, the Arts & Crafts movement inspired many amateurs to take up a needle. Adult art programs and needlework societies sprang up all over the country. Ladies' magazines like *The Modern Priscilla* and shelter periodicals like *Keith's Magazine* featured many "how-to" articles encouraging women to make stenciled or embroidered home textiles. Many of them were of dubious usefulness and hardly in the Arts & Crafts spirit of aesthetic minimalism.

Needlework entrepreneurs were quick to notice the greater market for kits that were considerably less expensive to purchase than finished embroideries. In addition, stenciled or painted patterns merely accented with simple embroidery like satin or stem stitches were quick projects for the very busy twentieth-century housewife. The best qualities of Arts & Crafts design and philosophy can be seen in many of these kits. To keep the patterns simple enough for an inexperienced sewer, designers had to create uncomplicated motifs. The charm of these extremely basic designs compares favorably with the more complicated and sophisticated stitchery of European Arts & Crafts needlework. Even projects meant to be richly embroidered used a minimum of stitch styles and often featured a forgiving black outline stitch in case the fill-in satin or darning work was not evenly accomplished. For once, in a uniquely American blend of entrepreneurial spirit and aesthetics, the Arts & Crafts tenets of quality and affordability were actually realized.

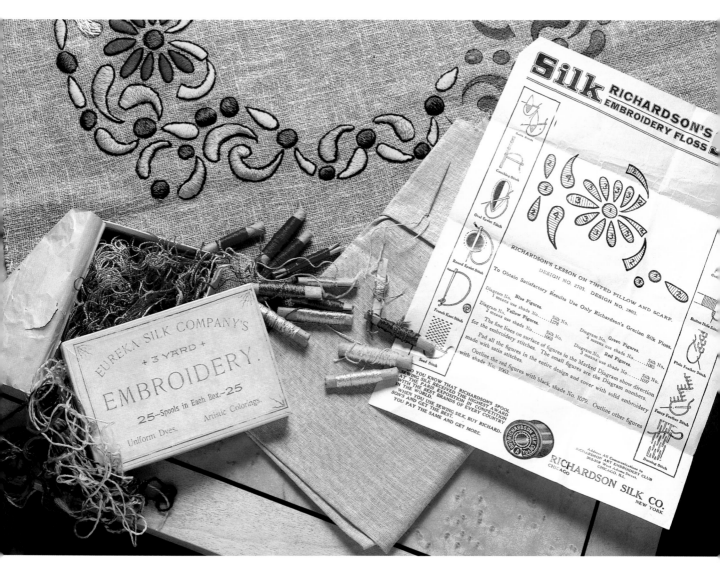

A rare complete and partially finished Richardson embroidery kit, including instruction sheet,
backing fabric (usually purchased by the embroiderer and not included in kits), and silk floss.
The embroiderer carefully wound some of the floss on rolled cardboard spools.

PHOTOGRAPH BY PHIL BARD

Stenciled Fabric

Painting on fabric is a bit more complicated than painting on walls or furniture. The paint needs to be flexible enough to bend with the fabric without cracking and it needs to stand up to washing and dry cleaning. Early formulas of paint for stenciling are quite daunting, featuring pigments diluted with kerosene or gasoline.

Precut stencils were sold directly by ladies' magazines. Packages of several designs were priced at about a dollar. The patterns were cut from heavy brown paper. They were varnished before painting to strengthen and seal the paper and they were quite durable.

Stenciling today is easier and safer than in the past. Nontoxic water-based textile paints are commonly available at crafts stores. Several contemporary designers produce precut stencils in Arts & Crafts motifs (see Resources), and these templates are produced on translucent plastic instead of paper, so it is much easier to place motifs and align borders. If you want to cut your own stencil, it is much easier nowadays.

To cut your own stencil, you need a drawing or photocopy of a design, a sheet of glass several inches larger in area than the design and with a taped edge, a sheet of acetate, masking tape, and a small sharp matte knife like an Xacto blade. If you are adapting a design, make sure it will work as a stencil. Take time to plan how you will cut, and try to plan only one overlay. If you have complex interlocking lines, you will need at least two stencil overlays, which will require careful pattern matching. Tape the original to the glass with the design facing down. Turn the glass over so that you can see the design and tape the plastic to the glass over the design. Following the lines of the original, carefully cut out the stencil. You will probably find that it is easier to cut accurately if you pull the blade slowly toward you. Turn the glass as necessary. If you make a mistake, you can repair it with a small piece of masking tape.

If you get really involved in cutting stencils, you may want to invest in a stencil cutter. It has an electrically heated tip, somewhat like a ballpoint pen, that cuts through the plastic faster and with less effort than a knife.

To paint with a custom or purchased stencil, you will need textile paints; a plate or palette on which to mix the paints; several stencil brushes (one for each color is best); water; plastic sheeting; pushpins; spray-on repositionable adhesive (available in art-supply stores); an awl, chopstick, or skewer; and of course, your fabric. Find a work surface large enough to lay the entire piece of fabric flat. It needs to be a surface on which you can fix the fabric with pushpins. Unless

Stenciled guest towels by
Prairie Textiles.

PHOTOGRAPH BY
PHIL BARD

CHRISTMAS GIFTS MADE WITH OUR
Stencil Outfits

Stencilling is the latest and most popular form of fancy work. This is because of the ease with which this pleasant occupation is carried on and the satisfactory and lasting results which you obtain without previous experience. You can easily stencil curtains, pillow covers, scarfs and other Christmas Presents at an economical cost if you will order one of our Stencil Outfits.

Send for Our Free Stencil Book

This book of simple instructions tells how to use our ready prepared stencil colors which are durable, brilliant and do not fade when the fabric is washed. It illustrates our original stencils, cut and ready for use. It gives many color suggestions and tells just what kind of fabrics are most suitable.

Stencil Outfit A, illustrated above, consists of, 1 Stencil Brush, 3 Ready-Cut Stencils, Book of Instruction, Stencil Paper and 12 tubes of Stencil Colors, also 1 tube each Stencil White, Ivory Black and Stencil Medium—Price $1.50.

THE SHERWIN-WILLIAMS CO.
DECORATIVE DEPARTMENT
661 Canal Road, N. W., Cleveland, O.

the fabric is very heavily sized, you will not need to prewash it. Natural fiber fabrics with fairly smooth surfaces work best. Be sure to buy a little extra fabric to test colors and practice on. Remember, the color of the fabric will affect the color of the paint. Very dark fabric requires special techniques for stenciling.

Press the fabric and pin it down. Spray the back of your stencil with the repositionable adhesive. This allows you to place the stencil firmly on the fabric but to move it easily. Lay out your paint colors on the palette. Do not thin the paint unless it is very, very thick. Watery paint will bleed under your stencil edges. If you want pale colors, add white or use a very dry transparent stenciling technique. Test the colors and practice your painting on a piece of fabric. Paint all the colors in your design before lifting the stencil. Once it has been moved, it is impossible to replace it exactly in the same spot. Make sure your brush is evenly covered with paint, but do not load it. A loaded brush will spread paint under the edges of the stencil. Your goal is to produce a nice even, dry-brush technique, with color that is smooth but not thick. Apply the paint with a gentle pounding motion, holding the brush straight up and down. Do not use a stroking motion. Again, this will keep the paint from seeping under the edges of the stencil. If your design has delicate bits that seem to lift as you paint, use an awl or chopstick to hold them in place as you paint.

If you see small areas where the paint is too thin or the edge of the design is broken or blurred when you lift the stencil, you can touch it up with a small brush. This works best with minor problems, as the paint will look different when it is brushed on. If you have a lot of broken edges, consider covering them with the traditional Arts & Crafts technique of outlining with an embroidered stem stitch.

Dry the fabric overnight. Using a pressing cloth, press it with a hot iron to set the color. If the paint smears or comes up on the pressing cloth, you will know that you did not let it dry long enough.

Sewing

As we have seen, most Arts & Crafts embroidery was done with a few simple stitches. Freestyle embroidery (as it is often called to distinguish it from counted cross-stitch) can be a technically complex art. But for American Arts & Crafts textiles, most stitching was done with the stem stitch, satin stitch, and darning stitch with an occasional French knot added.

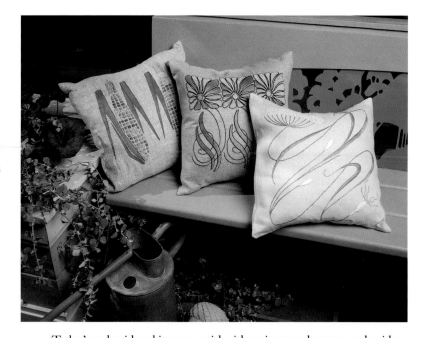

Original designs from Prairie Textiles, available as embroidery kits. From left to right: "Corn," "Aster," and "Allium."

PHOTOGRAPH BY PHIL BARD

New technologies developed at the beginning of the twentieth century enabled the thread industry to produce a wide selection of threads and colors for home embroidery.

Today's embroidery kits come with either six-strand cotton embroidery floss or perle cotton. The six individual threads that make up embroidery floss are meant to be sewn so that they lie flat next to each other, making a smooth reflective surface. Because they are separated, they may be pulled apart so that you can sew a finer stitch with only three strands, for example. Your kit instructions will tell you if you should separate the floss.

Perle cotton comes in several weights and is made from two strands twisted together like rope. When sewn with a satin stitch, it has a more matte finish. It is particularly attractive for edging designs in the stem stitch, giving the appearance of a narrow rope edge. Perle cotton is available in fewer colors than six-strand floss and can be difficult to find.

If your thread label does not say that the thread is colorfast, test the dye with a damp cotton ball. If the color rubs off, you should prewash the thread to prevent it from bleeding onto your fabric. Remove all labels and soak each color separately for several minutes in eight ounces of water with one tablespoon of white vinegar. This should set the color.

For your first embroidery project, I recommend purchasing a kit. Let an expert choose the appropriate fabric, calculate the amount of thread, transfer the design, and leave the fun part for you.

The nicest embroidery contains smooth, even stitching on unpuckered fabric. To achieve this, you should use an embroidery frame or hoop to hold the fabric evenly taut as you sew. This is very important. Do not try to sew with the fabric spread on your knee or a table. Frames can be adjusted and will hold your entire project flat, but they are more expensive, and because of their size, they can feel clumsy at first. Embroidery hoops are very inexpensive. They come in metal or bamboo with an adjustable screw to tighten the outer hoop, or with a plastic outer hoop that holds a metal ring under tension. The bamboo or wood hoops are the easiest on the fabric and provide a nice gentle tension. Try to plan your sewing so that finished stitching will not be crushed in the hoop as you move it. If this is unavoidable, you can cover the stitching with a small scrap of muslin, or, if it is not long fragile satin stitching, hoop over it very gently. If the stitches become flattened, washing them will usually reshape them. For beginners, an eight-inch-diameter hoop is a good workable size. Do not leave your work on the hoop—it may crease it permanently.

Tools for art needlework.

Most instructions for embroidery show the needle entering and leaving the fabric in one movement so that you can see clearly how the stitch is made. However, this is not the best way to sew unless you are very experienced. Sew each stitch in two movements, stabbing the needle into the fabric and pulling the thread all the way through to the back, then bringing the thread straight up to the front again. This will make it easier to control the size of the stitch and to keep the strands smooth and untwisted.

Use a good-quality needle with no blackened areas that come from skin acid and can rub off on your fabric. For working on linen with an irregular weave, standard in most kits of Arts & Crafts designs, I recommend a chenille or embroidery needle. These have a large eye and a sharp point. Tapestry needles, with a large eye and a blunt point, will slip between the fibers of the fabric and never split a thread. But I find it more difficult to get an even stitch with tapestry needles. Use a tapestry needle if you are sewing on even-weave linen or embroidery canvas.

Feel the needle with your fingernail and find the side of the eye that has a slightly larger groove. This side of the needle will be easier to thread. Use a length of thread that is no more than fifteen inches long. A longer thread will twist and knot and will be much more difficult to lay flat.

The finest embroidery does not have knots on the back. Knots make a lump and in time will come undone. To start an area of satin stitch, use a waste

Recommended
Needles
for Embroidery
Threads
•
6-strand floss:
#3 embroidery needle
20/22 chenille needle
•
3-strand floss:
#8 embroidery needle
22/24 chenille needle
•
#5 perle cotton:
#6 embroidery needle
20 chenille needle

How to sew a padded satin stitch, *Needle Art*, 1920.

knot. Make a small knot at the end of your thread and trim off the fuzzy end. If you sew from left to right, insert the needle into the front of the fabric an inch to the right of the starting point of your sewing. Draw the thread to the left across the back of the fabric and in the path of your stitching. Bring the needle up at the start of your stitching, and as you satin stitch you will sew over the tail of the thread. When your stitching is near the knot, cut it close to the surface and allow the thread to withdraw to the back of the fabric. You will have a smooth thread tail secured under the satin stitching.

The trick in satin stitching is keeping a smooth outline. It helps to aim for the outside edge of the pattern.

Many satin-stitch designs are pad-stitched for added dimension. Pad-stitching is simply a first layer of satin stitching done at right angles to the cover stitching. Since it does not show, it can be done with waste thread of any color.

Start stem or outline stitching with a similar technique. Make a waste knot and take a stitch into the front of the fabric about an inch along the stitching line. Bring the needle to the beginning of the line and, as you sew, take your backstitches over the thread tail. Feel the tail with your fingers and push it gently forward and back so that you sew over it and not through it. Stem stitches should generally be about three-sixteenths of an inch long. Take shorter stitches for more control when sewing curves.

How to sew the stem stitch, *Needle Art*, 1920.

Using a Knot—The Exception That Proves the Rule

If your edge stitch circles a motif or otherwise provides a stitched area to conceal the start, try this simple technique: Make a small knot in your thread. Using a sharp needle, stitch up through the back of the fabric through a fiber of the woven fabric and back through the closest hole. This makes the smallest possible pin stitch, and sewing through a fiber holds the knot to the fabric back. The small knot will not distort the stem stitch.

Finish your stitching by employing essentially the same technique in reverse. Take a stitch up through the fabric in an area that will eventually be covered with stitching. Insert the needle back into the fabric over one fiber of the fabric. The weave will close around the embroidery thread and the thickness of the thread will pinch around the fiber, holding it in place. Leave a thread tail on the wrong side to be covered by stitching.

You can use this same technique with a line of stem stitching. To catch the thread tail on the back of your embroidery, push it gently to the right and then to the left as you stem stitch to catch it in your stitch without tangling.

Hemming and Finishing

Table linens and other flat pieces are usually finished with a hem or pin stitch. This is a type of drawn work intended to make an attractive, sturdy, finished edge that looks equally attractive from either side of the fabric.

Press up the hem and mark the line where its upper edge falls. Using a pin or needle, release a thread along this line and pull it out. If it breaks as you are pulling on it, use the pin to start it again where it broke. The pulled thread will leave an empty area in a line along the fabric like a small weaving flaw.

Work on the back of the fabric, using a single thickness of sewing or darning thread that matches the fabric. Take a small stitch in the fold of the hem, then take a backstitch into the drawn thread line, wrapping your stitch around three or more fibers (depending on the weave of the fabric). Continue, making sure to stitch evenly and to catch approximately the same number of fibers every time. As you draw the fibers together by wrapping them, you make a tiny row of holes along the top edge of the hem. This masks the hem fold on the wrong side so that both sides of the fabric look finished.

When you have completed your project, press it carefully on the wrong side with an iron. Use a well-padded ironing surface to avoid mashing your beautiful dimensional stitching.

A pin-stitched hem.

ILLUSTRATION BY
ANN WALLACE

Caring for Your New Linens

Once you have invested many hours of labor in a table runner or pillow, you will feel very protective and may not want to use it at all. Remind yourself that beautiful things that are also useful are the classic symbols of the Arts & Crafts movement. Use and enjoy your nice things—life is fleeting!

Household Linens

Table linens get the most abuse. After all, their main function is to protect more fragile surfaces, like wood, from moisture and the sun. Food may be spilled, vases overflow, and dust settles. Fortunately, Arts & Crafts linens are usually made from linen, or sometimes, cotton/linen blends, which are easy to care for. If your pillow or runner is on display, try to clean it once a year, especially if you live in a city or have a lot of dusty renovation going on. Remember that the dust you wipe off the wooden furniture is also settling on the fabric. An accumulation of dust will permanently damage fibers and hasten rot.

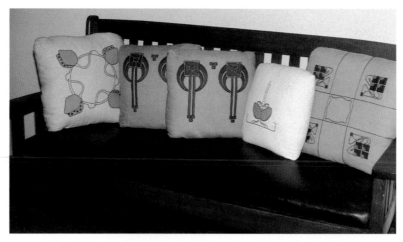

Pillows from Arts & Crafts Period Textiles, from left to right: "Seedpod,"
"American Beauty" (blue), "American Beauty" (red), "Lotus," "Checkerberry."
"Seedpod," "Lotus," and "Checkerberry" are from Gustav Stickley's Craftsman
Workshop. "American Beauty" is adapted from the 1910 H. E. Verran design
(compare colors with the faded vintage pillow on page 25). Arts & Crafts
Period Textiles produces many embroidery kits.

PHOTOGRAPH COURTESY ARTS & CRAFTS PERIOD TEXTILES

Table linens get the most exotic stains. The best stain-removal technique is to take care of the problem with speed. The sooner you treat a stain, the easier it will be to remove. Don't set it aside for laundering later. Immediately flush the fabric repeatedly with cold water. Add mild soap. If necessary, scrub gently with an old soft toothbrush. If none of this works, you may try an enzyme cleaner. Test the cleaner on a seam to see if it fades the fabric. Leave it on for as brief a period as possible, and do not use it directly on embroidery.

United States law requires that all textiles be sold with instructions for their care. Unfortunately, since few people today have the skill or equipment to properly launder, most manufacturers simply recommend dry cleaning, even if it is not the best method. If your textile is embroidered linen, it is probably washable. Your main concern will be the color stability of the embroidery. Reds, blues, and black are the least colorfast. Test by pressing the embroidery between two moistened (not soaked) cotton balls. An unstable dye will bleed slightly into the cotton. If the embroidery is only slightly noncolorfast, you may wash it anyway if you are careful. Use cold water and mild soap (like Ivory Snow). Do not use detergents or chemical spot removers. Their stain-removal properties will

actually accelerate bleeding. Use a plastic basin or sink that allows plenty of room for the fabric. If you can spread it out in a bathtub, that's even better. The idea is to make sure the unstable areas do not have the opportunity to transfer their color. Keep the fabric moving gently. Do not leave it to soak. A small embroidered red leaf, left soaking and pressed up against a clean white linen, will surely leave an imprint. Two or three minutes of washing should suffice. Rinse thoroughly again in cold water. Roll in a towel and squeeze gently to remove water. Do not crush or crumble. If possible, let it dry flat or partially flat on a clothes rack. Do not put it in a dryer—even on a delicate cycle.

Most importantly, don't let these instructions intimidate you. Linen is very strong and dyes are more stable then ever. The only problems I have had with bleeding have been when, in desperation, I have used a powerful enzyme cleaner like Shout. By all means, test your textile the first time you wash it, but don't let the fear of laundering it keep you from preserving your handiwork by keeping it clean.

Embroidered pillow with unusually lavish double-ruffled edge, *The Modern Priscilla*, 1909.

If you are able to dry your textile on a flat surface, it will need only a light pressing. Today's irons do not get as hot as in the past, which makes them safer and less likely to scorch fabric. On the other hand, linen requires high heat for a good pressing. I find this frustrating, so I search out old irons at garage sales. But these have their own problems. They can heat erratically and give you a nasty burn.

The old-fashioned way to press linen is to start with a damp fabric and iron with high heat on the wrong side until dry. The dampness provides some protection against scorching and the press will be very smooth and crisp. However, this is time consuming and you can get almost as nice a result by just moistening the fabric with a spray bottle. Some newer linens may water mark. To remove water marks, simply dampen the entire textile. I am not a big fan of spray starch, but it can add a bit of body to your fabric. It seems mainly to sit on the fabric surface and gum up the iron. I prefer liquid starch. Add about one cup to a gallon of water. Immerse the fabric (do not rinse) and iron damp. Do not use starch if you are storing your fabric. Over a long period of time, starch will attract insects, create mildew, and damage fibers.

Linen actually gets more wrinkle-resistant with repeated washings as fibers soften. Manufacturers are working to develop this property in new fabric, and more expensive linen will have a softer hand. However, all linen will actually improve with careful laundering. This is part of the pleasure of owning and caring for fine textiles.

Store your linens rolled rather than folded if you can. Fibers can break or stains can develop along creases. If you must fold them, refold your linens with different crease lines from time to time.

Curtains

Elaborately constructed drapery with lining, pleating, and trim, should be dry cleaned by a professional. Simple curtains without lining and made from natural fibers may often be washed. If the fabric was washed before the curtains were made and they are simple and informal, they may even be machine washed. The main difficulty with curtains is pressing them. Because they are large, one part seems to become creased as you are ironing another part. People used to dry their curtains on adjustable curtain frames so that they needed little or no ironing. In addition, the frame prevented shrinkage and dried the curtain to the exact window measurement. Unless fabric is tightly woven, it is quite malleable and can be distorted several inches in width or length, depending on the direction you iron. Professional workrooms use large ironing tables to minimize distortion.

Since no one today has this kind of elaborate laundry setup at home, it may be best to send your curtains to the dry cleaner. Use a reputable cleaner, preferably one with cleaning facilities on-site. If your curtains are simple, you may try bulk dry cleaning. Your curtains will be run through a dry-cleaning machine but not pressed. They will not be as creased as if they had been washed.

Curtains get dustier than almost any other home textile, since dust from both outdoors and indoors falls upon them. Try to clean them once a year, as the embedded dust will shorten their life. Besides sunlight, curtains are most frequently damaged by rainwater. In this era of acid rain, the liquid that comes from the atmosphere is much more damaging to fabric than plain water. Remember to close your windows if the weather looks bad, or keep the curtains open. If a curtain is rained on, try to rinse it at once. Only water can remove a water mark, so you will have to decide to risk rinsing your curtain or leaving it stained. Water marks from a leak in the roof or window frame (common enough in old houses) are extremely difficult to remove as the water contains all kinds of unknown grime from the walls of the house. Rinse immediately and spot wash with a mild soap. Lined drapes are more protected from the sun, and drapery lining fabric is usually treated to give a measure of protection from the weather if a window is left open. But the simple curtains favored for Arts & Crafts interiors will be more directly exposed to the elements. Don't be afraid to clean them.

Vintage Textiles

If you have a fine, valuable piece, have it cleaned or repaired by an expert in textile conservation. A local museum or university arts program may be able to recommend someone. The care of museum-quality textiles is a very special art, not for the untrained.

On the other hand, many charming but less precious Arts & Crafts textiles are available for considerably less money. However, they may be slightly damaged or stained. Linens and cotton can be improved considerably with washing and pressing. Remember to test the embroidery to make sure it is colorfast. Silk is very fragile. Old silk splits like parchment and may actually disintegrate if washed or cleaned. Luckily, such fabric was not often used for home textiles. Silk embroidery thread is also fragile. Always check silk thread for colorfastness before washing. If silk embroidery is frayed and split, it will continue to deteriorate and cannot be saved. Silk thread is dyed in acid colors that are soluble in warm or hot water. If colors are pale, silk may be successfully washed in cold water, but *dry* dry cleaning is recommended.

Many early drapery and upholstery fabrics were made of wool and have usually been damaged by moths. Hold the piece up to the light and look for weaknesses in the weave. It may be worth it to reweave or darn a few small holes. If you really object to a stain, don't purchase the textile, since it probably won't come out. Remember, the most important factor in spot removal is speed, and that stain has probably been there for decades.

Linen is particularly susceptible to rust spotting. These small brown spots come from mineral deposits in the original rinse water. The only way to avoid them is to rinse with distilled water. They really cannot be removed without damaging the fabric. Yellow streaks in white linen can be bleached out with lemon juice or peroxide. To bleach a small area selectively, make a paste of lemon juice or peroxide and soap flakes and brush it gently onto the stain. Leave it on for about one minute and rinse.

"Men were not intended to work with the accuracy of tools, to be precise and perfect in all their actions."

—*John Ruskin*

Never use bleaches (including lemon juice) on linen that has silk embroidery. Bleach lightens cellulose fibers (linen and cotton, made from plant products) but is damaging to protein fibers (silk and wool, made from animal products).

•

Many women's magazines and old household references contain recipes for removing stains. Do not use these formulas. Many recommend using strong chemicals like oxalic acid, carbon tetrachloride (no longer even available), or salt, which actually sets stains. Furthermore, the chemical makeup of dyes in inks, paints, and oil-based products has changed considerably over the years.

CONTEMPORARY ARTISANS

The Arts & Crafts movement continues to be an inspiration to craftsmen today. Many areas of the country are lucky to have a shop that specializes in the Arts & Crafts style, but most artisans sell their work through mail order, the Internet, and craft shows. Whatever their personal interpretation of the Arts & Crafts philosophy, these artisans delight in developing a relationship with their customers and maintaining a hands-on involvement in their work.

KELLY MARSHALL
New Technology in Service to Old Ideals

Kelly Marshall is a weaver whose work was inspired by the geometric designs of the Prairie School and the Arts & Crafts architecture of her native Minnesota. She makes custom-designed rugs as well as wall hangings, table runners, pillows, and fabrics.

Marshall has been interested in textiles ever since she was a child. She began embroidering from kits, learned weaving from her grandmother, and studied weaving in college. She studied applied design at the University of Minnesota and at the Folk High School in Sweden. She visited Carl Larsson's house, a renowned example of the Swedish Arts & Crafts design, and admired the work of his wife, who was a weaver and embroiderer. Marshall did not fall under the influence of the Arts & Crafts style until friends who were collectors began to point out interesting Prairie School design in midwestern architecture. To this day, Marshall is inspired by architectural detail; iron gates, masonry, woodwork, plaster detail, and stained glass are sources for her designs.

In order to complete commissions for interior designers and private clients, Marshall has three looms and four part-time weavers who work with her in her 1,800-square-foot studio in Saint Paul. Her Arts & Crafts style brings warmth to projects like the North Memorial Hospice Center and St. John's Hospital, and her weaving has been featured in magazines and at exhibits at fine craft shows throughout the country. All her work is made to order and

Woven textiles can also be used as table runners.
"Arts & Crafts" by
Kelly Marshall.

PHOTOGRAPH COURTESY
KELLY MARSHALL

Kelly Marshall's textiles are inspired by the highly abstract forms of the Prairie School, and she often uses architecture as a design source. This rug is called "Iron Gate."

PHOTOGRAPH COURTESY KELLY MARSHALL

her specialty is developing color palettes and compositions to coordinate with furniture and accessories.

Marshall is not reluctant to use modern technology to produce her beautiful weavings. She designs on a computer because using a program gives her the grid she needs for patterning and allows her to plan repeats. She sends computer-generated color renderings (with actual thread samples attached) to customers for approval, and also uses a computer-aided loom, which speeds production and ensures accuracy.

Marshall uses a rep weave for her rugs. This is a technique that produces a thick-thin-thick-thin-ribbed texture. Marshall uses only natural fibers, and the mercerized cottons she uses give her pieces a delicate sheen. The high density of the interlocked linen and cotton threads is durable and extremely practical. Her rich colors come from fiber-reactive dyes so they resist fading and bleeding. Marshall's rugs are strong, solid, reversible, and—unbelievably—machine washable.

ANN CHAVES
A Commitment to Handwork

Ann Chaves has been surrounded by needlework all her life. Her Glasgow grandmother taught her to do needlework, and as a small child she spent as

many hours as she could visiting a neighbor who was a weaver. She grew up in East Aurora, the home of the Roycrofters, but did not truly discover the Art & Crafts movement until she moved to Pasadena, California.

Chaves loved the aesthetics of the movement and began by collecting furniture for her home. The textiles she saw did not satisfy her as the quality of the embroidery was often indifferent and she often found the color schemes gaudy. She prefers to create her own designs using the classic Arts & Crafts technique of making studies from nature and translating them into more formal motifs.

After making a few pieces for her own house, a local antiques dealer asked to show some of Chaves's work. A few other shops carry her work, but she mainly works by commission. She loves to do special pieces for people who will give her the freedom to work her original designs. Occasionally Chaves will duplicate a piece, but she prefers not to, often guaranteeing clients that the embroidery work they buy will remain as one of a kind. She works on one piece at a time, doing everything by hand except the assembling of pillow tops. Since

Ann Chaves's hand embroidery is strongly influenced by the naturalistic designs of William Morris.

PHOTOGRAPH BY
PHIL BARD

92

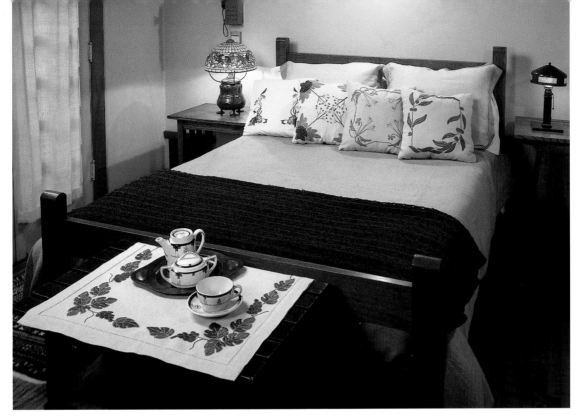

Ann Chaves's rich embroidery brings vibrant color to a simple bedroom.

PHOTOGRAPH BY PHIL BARD

Chaves does all the work herself, and a project can take as long as two months, there is often a long wait before she can begin a commission.

The process for Chaves starts with sketches taken either directly from nature, from photographs, or from her favorite turn-of-the-century nature studies. She translates these sketches into more stylized designs. Chaves points out that she likes lots of movement and her designs are less conventionalized than many Art & Crafts motifs. She transfers the design to the linen with a vellum pattern.

For embroidery, Chaves uses layers of rich colors. She loves working with color, developing a sophisticated and complex interplay of shades. She uses mainly perle cotton, but sometimes silk, and often embroiders on her own hand-woven linen. For Chaves, the ideal is to control the entire production of her embroidery pieces, to spin her own flax and weave it into a fine linen, finishing it with her own embroidery.

Additional Reading:

Ewald, Chase Reynolds. *Arts & Crafts Style & Spirit: Craftspeople of the Revival* (Salt Lake City: Gibbs Smith, Publisher, 1999).

RESOURCES

Carpets

Blue Hills Studio
400 Woodland Way
Greenville SC 29607
803-232-4217
Custom-made rugs.

Jax Rugs
109 Parkway
Berea KY 40403
606-986-5410
www.4berea.com/jaxco
Reproductions and original
designs.

Kelly Marshall
2402 University Avenue
Saint Paul MN 55114
651-645-3125
www.2.bitstream.net/~cwi
Custom rugs and other
weavings.

Nature's Loom
32 East 31 Street
New York NY 10016
800-365-2002
www.majorloom.com
Wholesaler of rugs in Arts
& Crafts designs.

Finished Textiles, Yardage and Kits

Ann Chaves
Inglenook Textiles
240 North Grand Avenue
Pasadena CA 91103
Contact by mail.
Custom embroidery.

Ann Wallace and Friends
Prairie Textiles
Box 2344
Venice CA 90294
213-617-3310
www.webmonger.com/
annwallace/
Custom window treatments,

finished textiles, yardage,
hardware.

Backhausen Interior Textiles
33 Karnter Strasse
A-1015, Vienna, Austria
43-1-514 04-0
www.backhausen.com
Wiener Werkstatte textiles
by Kolo Moser and Josef
Hoffman (to the trade).

Carol Mead
434 Deerfield Road
Pomfret Center CT 06259
203-963-1927
Printed pillows.

Dianne Ayres
Arts & Crafts Period Textiles
5427 Telegraph Avenue, Suite
W2
Oakland CA 94609
510-654-1645
Finished textiles, custom em-
broidery, kits, yardage, hard-
ware.

Michael Fitzsimmons
Decorative Arts
311 West Superior Street
Chicago IL 60610
312-787-0496
Reproduction and antique/
finished textiles, also rugs.

Textile Art Artifacts
1847 Fifth Street
Manhattan Beach CA 90266
310-379-0207
Specialist in antique Arts &
Crafts textiles.

J. R. Burrows and Company
P.O. Box 522
Rockland MA 02370
800-347-1795
www.burrows.com
Candace Wheeler reproduc-
tion textiles, net curtains, also
carpets.

Heartland House Designs
741 North Oak Park Avenue
Oak Park IL 60302
708-383-2278
Frank Lloyd Wright and
Charles Rennie Mackintosh
designs in counted cross-
stitch.

Liberty of London
108 West 39th Street
New York NY 10018
212-391-2150

Sanderson and Sons
979 Third Avenue
New York NY 10022
William Morris textiles (to
the trade).

Schumacher and Company
939 Third Avenue
New York NY 10022
212-415-3909
Frank Lloyd Wright textiles
and carpets (to the trade).

Textile Artifacts
12589 Crenshaw Boulevard
Hawthorne CA 90250
310-676-2424
www.textileguy.com
Antique and reproduction
fabrics.

Trustworth Studios
Box 1109
Plymouth MA 02362
508-746-1847
Custom needlepoint and kits.

United Crafts
127 West Putnam Avenue
Greenwich CT 06830
203-869-4898
www.ucrafts.com
Finished textiles, also rugs.

Interior Designers

These designers contributed
directly to this book. Many
designers and architects ad-
vertise in *American Bungalow*
and *Style 1900*. A listing is
available in *Beautiful Necessity*
by Bruce Smith and Yoshiko
Yamamoto. Local assistance
may also be found through
preservation groups.

David Heide Design
710 Grain Exchange Building
Minneapolis MN 55415
612-337-5060

Suzanne Maurer & Associates
1823 Irving Avenue South
Minneapolis MN 55403
612-381-0283

Marti Wachtel
Circa Design
1376 Yosemite Avenue
San Jose CA 95126
408-998-2839

Periodicals

American Bungalow
123 South Baldwin Avenue
Sierra Madre CA 91024

Craftsman Homeowner:
The Official Publication of the
Foundation for the Study of
the Arts & Crafts Movement
at Roycroft
31 South Grove Street
East Aurora NY 14052
716-652-3333

Old House Interiors
2 Main Street
Gloucester MA 01930
978-283-320

Style 1900
333 North Main Street
Lambertville NJ 08530
609-397-4140
www.RAGOARTS.com

Stencils

Helen Foster Stencils
71 Main Street
Sanford ME 04073
207-490-2625
Precut stencils in Arts
& Crafts designs.

Amy Miller
Trembelle River Studio
and Design
P.O. Box 568
Ellsworth WI 54011
715-273-4844
www.trembelleriver.com
Precut stencils in Arts &
Crafts designs.

Viewing Other People's Houses

As authentic Arts & Crafts furnishings become more and expensive, it is ironic that the last affordable Arts & Crafts antique may be the house itself. Many neighborhoods are being revitalized, and homeowners often open their houses to tours and sponsor other projects to promote accurate restoration.

Tours sponsored by many neighborhood associations are one of the best ways to get ideas for your interior. Many of these organizations are run by volunteers and do not have formal headquarters or regular phone numbers, but they usually list their events and meetings in the Arts & Crafts press.

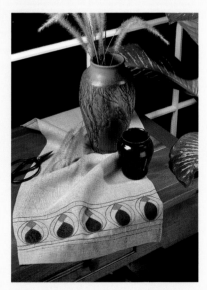

"Crocus" runner, contemporary
stenciled and embroidered textile
from Prairie Textiles.

PHOTOGRAPH BY PHIL BARD

**A very partial listing of some
yearly house tours and organizations.
Watch for their announcements.**

Pasadena Heritage Craftsman Weekend
Late Fall in Pasadena, California
626-441-6333

Bungalow Heaven House Tour
Spring in Pasadena, California

The Prairie Arts & Crafts Conference
Early Fall in Decatur, Illinois

San Diego Arts & Crafts Weekend
Early Spring in San Diego, California
619-297-9327

Craftsman Farms Symposium
Early Fall in Morris Plains, New Jersey
973-540-1165

The Grove Park Inn Arts & Crafts
Conference
February in Asheville, North Carolina
800-438-5800

Oak Park Arts & Crafts Conference
Early Fall in Oak Park, Illinois
708-383-2654

SUGGESTED READING

Adams, Steven. *The Arts & Crafts Movement*. Secaucus: Chartwell, 1987.

Anscombe, Isabelle. *Arts & Crafts Style*. New York: Rizzoli, 1991.

Bowman, Leslie Greene. *American Arts & Crafts: Virtue In Design*. Los Angeles County Museum of Art, 1990.

Burkhauser, Jude, ed. *Glasgow Girls: Women In Art and Design 1880-1920*. Edinburgh: Canongate, 1990.

Calloway, Stephen and Stephen Jones. *Style Traditions: Re-creating Period Interiors*. New York: Rizzoli, 1990.

Cathers, David M. *Furniture of the American Arts & Crafts Movement: Stickley and Roycroft Mission Oak*. New York: New American Library, 1981.

Cooper, Jeremy. *Victorian and Edwardian Decor from the Gothic Revival to Art Nouveau*. New York: Abbeville Press, 1987.

Crawford, Alan. *Charles Rennie Mackintosh*. London: Thames and Hudson, 1995.

Cumming, Elizabeth, and Wendy Kaplan. *The Arts & Crafts Movement*. London: Thames and Hudson, 1991.

Gere, Charlotte, and Michael Whiteway. *Nineteenth-Century Design from Pugin to Mackintosh*. New York: Harry N. Abrams, Inc., 1993.

Kallir, Jane. *Viennese Design and the Wiener Werkstatte: Galier St*. New York: Etienne/George Braziller, 1986.

Kaplan, Wendy, ed. *Charles Rennie Mackintosh*. London: Glasgow Museums/Abbeville Press, 1996.

Macfarlane, Fiona C., and Elizabeth F. Arthur. *Glasgow School of Art Embroidery 1894-1920*. Glasgow: Glasgow Museums and Art Galleries, 1980.

Makinson, Randell L. *Greene and Greene: Furniture and Related Designs*. Salt Lake City: Gibbs Smith, Publisher, 1979.

Mayer, Barbara. *In the Arts & Crafts Style*. San Francisco: Chronicle Books, 1992.

Morris, Barbara. *Liberty Design*. Secaucus: Chartwell Books, 1989.

Naylor, Gillian. *The Arts & Crafts Movement: a Study of Its Sources, Ideals and Influence on Design Theory*. London: Trefoil Publications, 1971.

Nebehay, Christian M. *Vienna 1900 Architecture and Painting*. Vienna: Verlag Christian Brandstatter, 1983.

Parry, Linda. *Textiles of the Arts & Crafts Movement*. London: Thames and Hudson, 1988.

____, ed. *William Morris*. New York: Harry N. Abrams, 1996.

Poulson, Christine. *William Morris*. London: New Burlington Books, 1994.

Smith, Bruce, and Yoshiko Yamamoto. *The Beautiful Necessity: Decorating with Arts & Crafts*. Salt Lake City: Gibbs Smith, Publisher, 1996.

Stickley, Gustav. *Collected Works*. Edited by Stephen Gray and Robert Edwards. New York: Turn-of-the Century Editions, 1981.

____. *Craftsman Furnishings for the Home*. New York: The Craftsman Publishing Co., 1912.

____. *Craftsman Homes, Architecture and Furnishings of the American Arts & Crafts Movement*. New York: The Craftsman Publishing Co., 1909; reprint: Dover Publications, 1979.

____. *More Craftsman Homes: Floor Plans and Illustrations for 78 Mission Style Dwellings*. New York: The Craftsman Publishing Co., 1912; reprint: Dover Publications, 1982.

____. *The 1912 and 1915 Gustav Stickley Craftsman Furniture Catalogs*. New York: Athenaeum of Philadelphia and Dover Publications, 1991.

Turner, Mark, and Lesley Hoskins. *Silver Studio of Design: A Design and Sourcebook for Home Decoration*. Devon: Webb and Bower, Exeter, 1988.

Watkins, Charmian. *Liberty Style, Decorating With Fabric*. New York: Simon & Schuster, 1987.

Wheeler, Candace. *The Development of Embroidery in America*. New York: Harper and Brothers, 1921.

____. *Yesterdays in a Busy Life*. New York: Harper and Brothers, 1918.

Wilhide, Elizabeth. *William Morris, Decor and Design*. London: Pavilion, 1991.

____. *The Mackintosh Style: Design and Decor*. London: Pavilion, 1991.

Winter, Robert, and Alexander Vertikoff. *American Bungalow Style*. New York: Simon & Schuster, 1996.